BLACKPOOL

THE POSTCARD COLLECTION

ALLAN W. WOOD

AMBERLEY

Cover: North Pier and Central Promenade *c.* 1910.

Dedicated to the best Mum in the world.

First published 2015

Amberley Publishing
The Hill, Stroud, Gloucestershire, GL5 4EP
www.amberley-books.com

Copyright © Allan W. Wood, 2015

The right of Allan W. Wood to be identified as the
Author of this work has been asserted in accordance with
the Copyrights, Designs and Patents Act 1988.

ISBN 978 1 4456 4490 5 (print)
ISBN 978 1 4456 4510 0 (ebook)

British Library Cataloguing in Publication Data.
A catalogue record for this book is available from the
British Library.

Typesetting by Amberley Publishing.
Printed in Great Britain.

CONTENTS

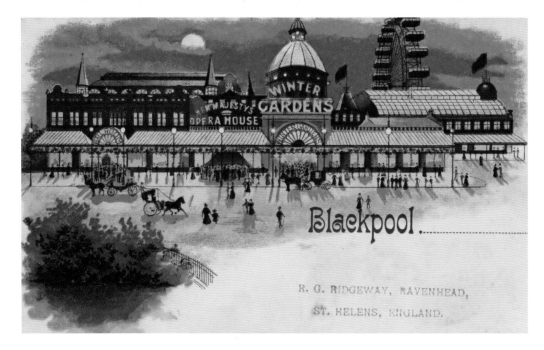

The Winter Gardens c. 1901 with Queen Victoria halfpenny stamp.

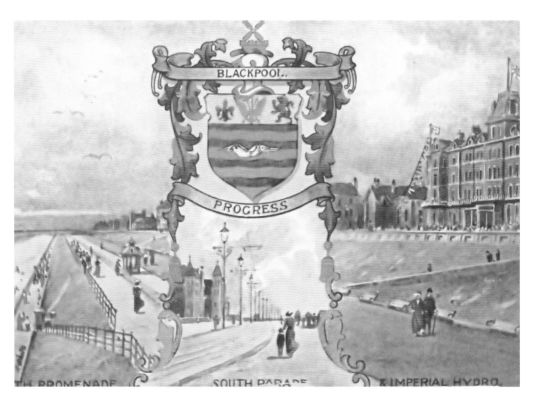

Early Heraldic multi-postcard c. 1910.

INTRODUCTION

The Sending of Postcards

The sending and receiving of postcards began in the mid-1890s, in the latter years of Queen Victoria's reign, and was initially discouraged by the Post Office in Britain, by its restriction relating to the size of the cards that could be posted and the restriction that only the address could appear on the stamp side of the card. However, from November 1899 the 'continental' size of postcards (the size we still use) was allowed and from January 1902 'divided back' cards were allowed where messages and the address could appear together on the back of the card and the boom in postcard sales began with millions of postcards being sent each year in the first half of the twentieth century.

Capturing the Changes

The views contained in the postcards sent from Blackpool in the 1890s provide a fantastic record of the physical and social changes that have occurred, as well as recording in some detail the development of Blackpool's frontage from Anchorsholme to South Shore.

Besides capturing the ever changing topographical developments of the town and primarily its promenade areas and its attractions, the postcards sent from Blackpool also record the changes in the various modes of transport in the town, the range and location of the accommodation available, the extensive number of entertainment venues available, the dress of the visitors and, to a degree, the growing prosperity of Blackpool's visitors.

In terms of changes to the physical features on the promenade, and leaving aside the many promenade widening and coast protection improvement schemes there have been over the years and can be seen on the postcards containing promenade views, the major changes to the skyline of Blackpool have probably been the loss of the Big Wheel in 1928, the changes to the Golden Mile, the various incarnations of what was The Palace/Lewis's site in the block north of the Tower, the recent loss in 2009 of the building that housed Yates's Wine Lodge in Talbot Square and the changes at the Pleasure Beach with much bigger and more exhilarating rides being constructed.

In respect of changes in transport, Blackpool has lost Central Station which, in its heyday, was one of the busiest stations in the world and the extensive railway land from Central to

South Station has been developed as a road directly into Blackpool from the motorway and mainly as a car park. Recently Bloomfield Road Bridge was demolished and the area adjacent to Bloomfield Road's West Stand rejuvenated. Also, the Blackpool Gateway Academy School (for 4–11-year-olds) opened in September 2013 on land adjacent to Seymour Road. North Station has been moved back to what was the 'excursion' platform building at the top of Upper Queen Street near High Street and the Dickson Road/Talbot road site has been blandly developed and used by various companies since the late 1970s as a supermarket and car park.

However, whilst the inland tramway routes have all long gone, Blackpool has kept faith with its promenade tramway and has, by the introduction of the Flexity 2 trams in 2011, ensured the tramway's existence well into the twenty-first century. In respect of vehicle transport, some of the postcard views in this book capture the days of horses and carriages and the almost empty carriageways before motor cars took over our lives and consumed most of the outside space. In respect of the changes in the style of dress over the last 120 years, most of the postcard views in this collection are from the first half of the twentieth century and show the styles prevalent of that time, where everybody (men, women and children) all seemed to wear hats or caps and when it was improper for a lady to show her legs above the ankles.

The most popular Blackpool postcard views have always been those of the tower, the promenade and the beach and the three piers. However Blackpool's many other attractions were also popular postcard subjects such as the Winter Gardens, The Palace, the Big Wheel and the Pleasure Beach. Visitors also often sent cards home to family and friends of the hotel/guest house or street/locality where they were staying, to form part of prized family collections or to provide information on their safe arrival, their accommodation, the town or the weather. Nowadays this information would be sent by email in a fraction of a second. Novelty, humorous, 'saucy' and 'multi' cards were also popular alternatives.

The Selection

There have been a number books of old postcard views of Blackpool published over the years and this book is not a collection of 'collectable' or rare/obscure postcard views of Blackpool. This collection focuses primarily on Blackpool's many major tourist attractions which, some 120 years after the introduction of postcards, remain largely the same and which have always been the most popular subject matter for postcards. *Blackpool: The Postcard Collection* is presented in five broad sections.

Section 1 considers postcard views from the late 1890s and draws upon views from a few very early postcards including court cards and postcards with 'undivided backs' (pre-1902) where only the address was allowed on the stamp side and whereby writing around (and on) the picture was not unusual. Section 1 also contains some very early album views, including an artistic 'aerial' view of Blackpool in the late 1890s as well as early stereoscopic photographs. The viewing of the stereoscopic views in the book, through a stereoscopic viewer, will probably surprise you.

Section 2 attempts to capture the rapid construction of the tower structure during 1893, together with postcards of some of the tower's many attractions and famous personalities who reigned there, as well as providing views of areas of the town of Blackpool between the early

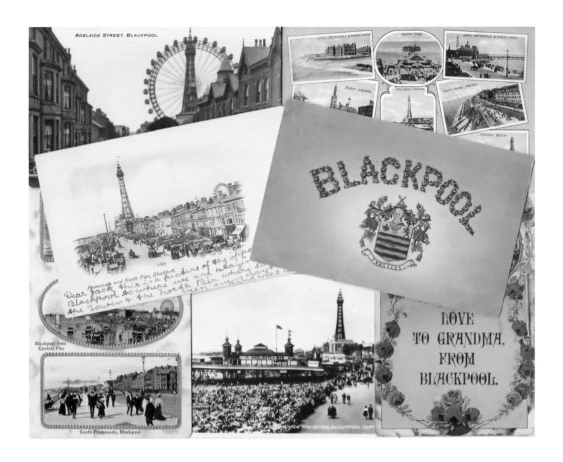

1900s and the 1930s, taken from the top of the tower. Section 2 also contains postcard views of The Palace, the Winter Gardens and their attractions, as well as the Big Wheel.

The postcards in Section 3 show the development of Blackpool's three piers at various times throughout their lives and also shows some of the rides at the Pleasure Beach in its early years and its location adjacent to the beach at South Shore.

Section Four includes postcard views of Blackpool's main hotels and others, including a small selection of guesthouse postcards. Section 4 also includes a selection of early comic and 'saucy' postcards as well as postcards depicting the Illuminations and illuminated trams.

Finally, Section 5 brings together what I have called a 'miscellany' of postcard views and includes a mixture of topographical and transport views from many parts of the town at different dates, mainly showing places and things that have changed significantly or are sadly gone forever, together with a few 'moments in time' postcard views relevant to Blackpool's short history.

The number of postcards sent from Blackpool since postcards were first allowed in the 1890s must be in the tens (if not hundreds) of millions and the number of different postcard views there are to collect and to choose from for this collection is immense. Whilst the aim of

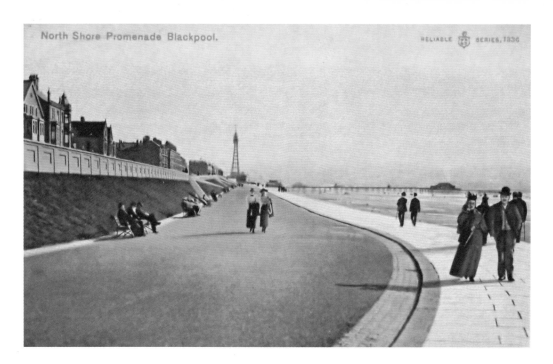

North Shore Promenade *c.* 1908 – Middle Walk.

this book is to do credit to the main attractions in the town, it is difficult to find 'new' views of the Tower and the other principal attractions and I have attempted to include as many as possible previously unpublished views. I hope you find something you enjoy.

Allan W. Wood
July 2015

SECTION 1

EARLY VIEWS

Blackpool Tower *c.* 1898.

BLACKPOOL. *18.10.99.*

Early Postcards

The sending and collecting of picture postcards first emerged as a craze on the continent in the 1890s, but the Post Office did not allow picture postcards to be sent by post until September 1894 and then the size of the card was restricted to the 'Court size' of 4¾ x 3½ and only the address was allowed on the stamp side. The odd-sized card at left (5¼ x 3¼) was posted to Leipzig in Germany on 18 October 1899 with a 1*d* Queen Victoria lilac stamp. The card below, although posted on 30 August 1904, is a standard court-sized card printed some years before.

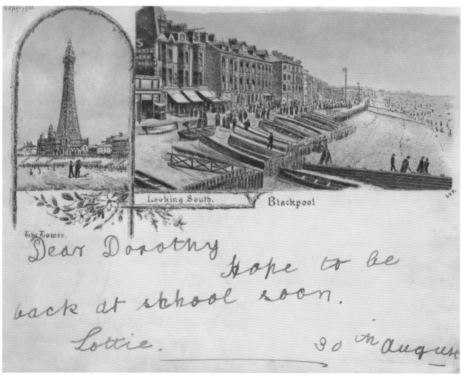

Looking South. Blackpool

The Tower.

Dear Dorothy
Hope to be back at school soon.
Lottie. 30 th August

Bailey's Hotel

Bailey's Hotel dates from the 1780s and remains the only hotel on the seaward side of the promenade. It was re-named the Hotel Metropole in 1896 and was owned by Butlin's between 1955 and 1998. It is now owned by Britannia Hotels. Raikes Hall Gardens opened in 1872 and was bounded by Church Street, Whitegate Drive, Hornby Road and Raikes Parade. It included a theatre, boating lake, aviary, monkey house, skating rink, racecourse, cricket ground and football ground. It could not compete with the Tower, Winter Gardens or the piers and closed in 1898 with the land sold off for housing in 1901. Blackpool FC played most of their games there between 1896 and 1899.

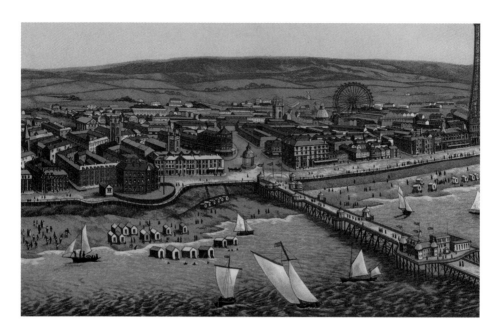

A View from Above

The artistic 'aerial' view of Blackpool in the late 1890s, with the tower, Big Wheel (1896) and its three piers, is taken from *Camera Series of Album Views of Blackpool* produced by Brown & Rawcliffe of Liverpool and purchased from Donnelly's Continental Bazaar of No. 33 Bank Hey Street. The Albion Hotel (1828) and the Lane Ends Hotel were on opposite sides of Church Street at its junction with the Promenade. Further on is the Prince of Wales Arcade building, housing a theatre, baths and market. This was demolished in 1897 and replaced by the Alhambra, becoming the Palace in 1904 and demolished for Lewis's in 1962.

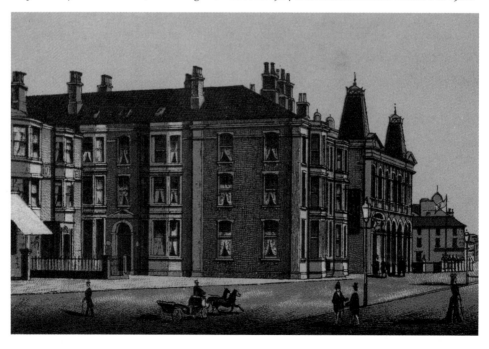

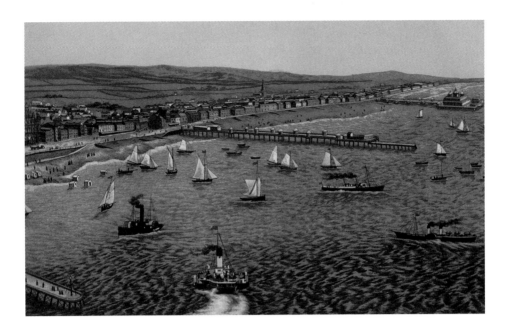

Piers and Sailing Boats

In this double-page spread, the artist has depicted the main attractions and has captured the growth of Blackpool around the late 1890s, but appears to have exaggerated the number of paddle-steamers and sailing boats plying their trade between the piers. To the left in the picture below is Dr W. H. Cocker's 'Aquarium', menagerie and aviary before its demolition in the early 1890s to make way for the Tower. The Royal Hotel was located between Heywood Street and Adelaide Street where Hull's Hotel had stood from the 1780s. In the 1930s the buildings were demolished and the classic Woolworth's Store was erected.

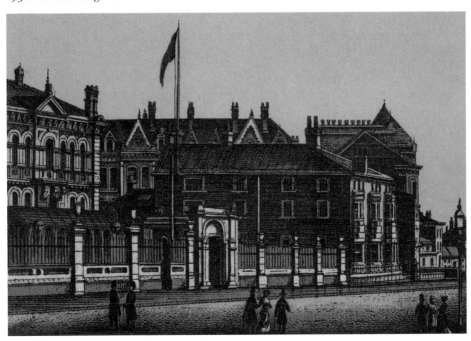

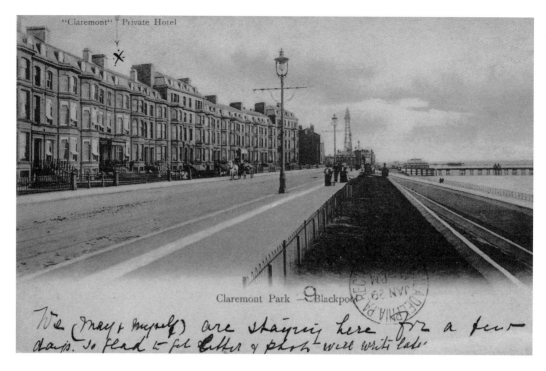

"Claremont" Private Hotel

Claremont Park — Blackpool

We (May & myself) are staying here for a few days. So glad to get letter & photo, will write later.

Lansdowne Terrace and Central Promenade

In November 1899 the continental size postcard of 5½ x 3½ became the standard size, albeit still restricted such that only the address could be written on the stamp side. As a result, messages were often squeezed onto the front of the card around (and sometimes over) the picture. In January 1902 the Post Office allowed the 'divided back' postcard and the boom in the sending and collecting of postcards in the UK began. Above is an early view of Lansdowne Crescent *c.* 1904, marked with an 'x' where the sender was staying at the Claremont Private Hotel. Below is a view looking south over Central Beach from the roof of Blackpool Tower.

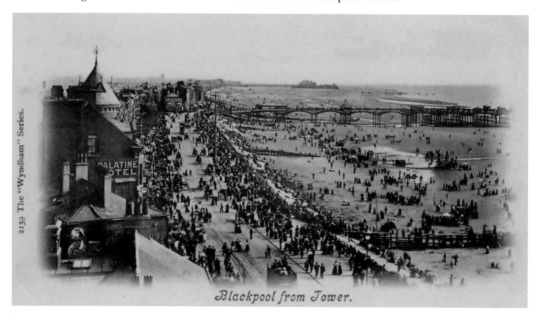

Blackpool from Tower.

THE SANDS, BLACKPOO

[handwritten message]

The Sands

The 1902 postcard above of 'The Sands, Blackpool' is from the Raphael Tuck & Sons *View* series and, as it is a very early coloured postcard, was most probably printed in Germany. Tuck were granted the Royal Warrant of Appointment in 1883 by Queen Victoria. The view in the April 1903 card below is taken from Central Pier looking across the beach at the promenade towards the Foxhall Hotel (smaller white building) with Tyldesley Terrace in the centre and the Manchester Hotel at the end of Lytham Road further to the right. The sender tells the recipient that the night was 'very wild', the 'weather this morning is like winter' but there is 'nice company in the house'.

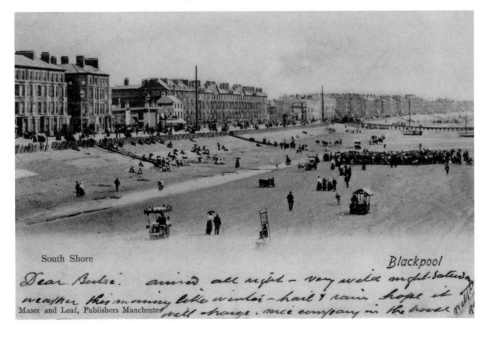

South Shore

Blackpool

Maser and Leaf, Publishers Manchester

[handwritten message]

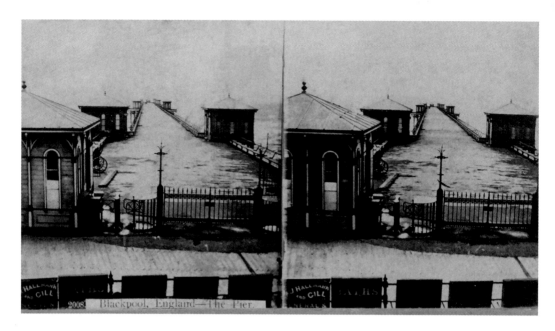

Stereoscope Cards 1

Stereoscope cards were generally available from the 1850s and became popular after the 1860s when the handheld stereoscope viewer created by Oliver Wendell Holmes was created. Cheap 'paper' stereo viewers can now be purchased and you will be surprised at how the picture jumps to life if you are able to view these pictures through one. Above is an early (1860s) stereoscopic view of North Pier before it was widened. Below is a stereo view of a cobbled promenade at Talbot Square taken in the 1890s.

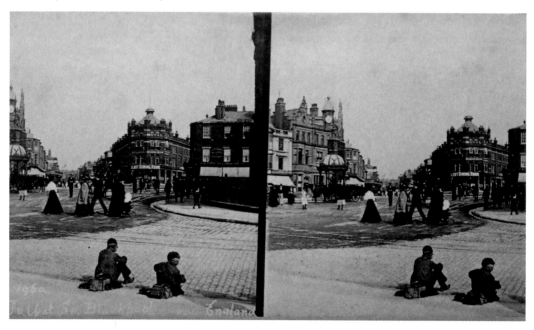

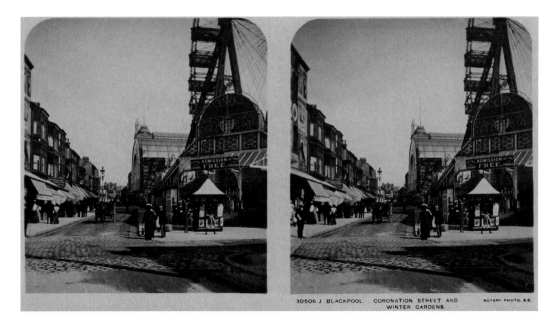

30506 J BLACKPOOL. CORONATION STREET AND WINTER GARDENS. ROTARY PHOTO. 6.6.

Stereoscope Cards II

Above is a fine stereoscopic view of the entrance to the Big Wheel on the corner of Coronation Street and Adelaide Road with the striking semi-circular arch and glass-covered roof of the Winter Gardens entrance at the top of Victoria Street and Church Street beyond. Below is an early 1900s view of Central Beach and the Tower with throngs of people on the beach (but note there are no deckchairs), boats on the slipway and its rather poor timber-post sea defences.

BLACKPOOL.

Panoramic View 1

Panoramic cards, although suiting the broad vistas of Blackpool promenade and its piers and the height of Blackpool Tower, were something of a novelty and were not widely sent or collected. The breadth of 'panoramic' postcards was approximately twice that of the standard (modern) postcard and they range in size from 9¾ x 4 to 11½ x 3¼. Above is a lovely colour view of Talbot Square, its drinking fountain, horse-drawn carriages and (to the right) the open-top *Motherwell* Tram No. 45, brought into service between 1901 and 1903. The postcard view also captures the entrance to North Pier with its Eastern-style pavilion and entrance buildings *c.* 1910.

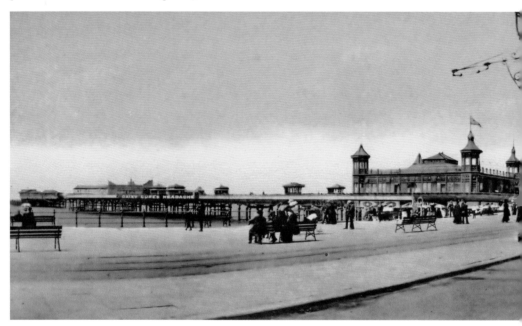

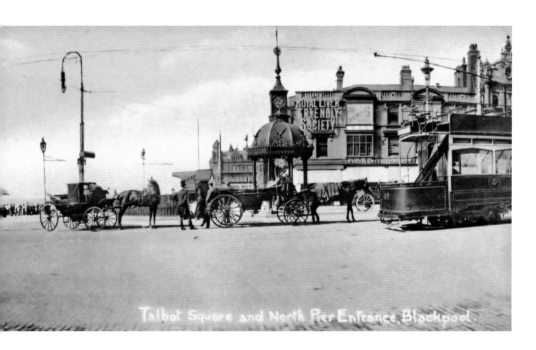

Talbot Square and North Pier Entrance, Blackpool.

Panoramic View II

The panoramic cards shown on these two pages were published by Albin's Bazaar of Church Street in the early 1900s and were available in both colour and black and white. Although they had 'divided backs' they could only be used with a halfpenny stamp if no more than a signature and the address section was used – otherwise a penny stamp was required. The view below is of Central Pier, the newly widened promenade (1904–5) whereby the tramway was separated from the road, and Blackpool Tower in the distance.

Central Pier and Promenade Blackpool.

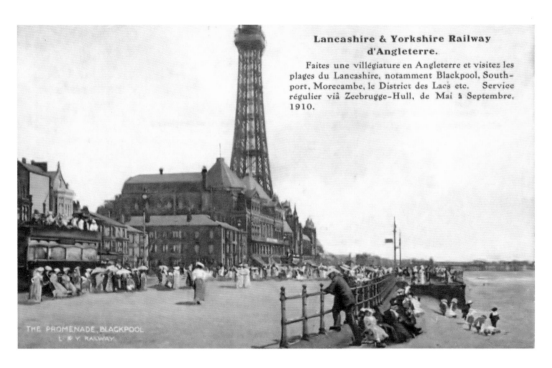

**Lancashire & Yorkshire Railway
d'Angleterre.**

Faites une villégiature en Angleterre et visitez les plages du Lancashire, notamment Blackpool, Southport, Morecambe, le District des Lacs etc. Service régulier viâ Zeebrugge-Hull, de Mai à Septembre, 1910.

THE PROMENADE, BLACKPOOL
L & Y. RAILWAY.

Lancashire & Yorkshire Railway

The Lancashire & Yorkshire Railway card (above) is from its 1907 set of 'West Coast Sea Side Resorts', overprinted in French to advertise its services from Zeebrugge to Hull to the resorts of the North West of England in May–September 1910. The colour postcard entices with a view of Blackpool Tower and the promenade. Below is a fine postcard view of the front of the Tower building advertising the Tower's many attractions, including the poster high to the left requesting patrons to 'See The Most Beautiful Dancing Room in the World'. The promenade in this area is now the site of the Comedy Carpet which was unveiled by Ken Dodd on 10 October 2011.

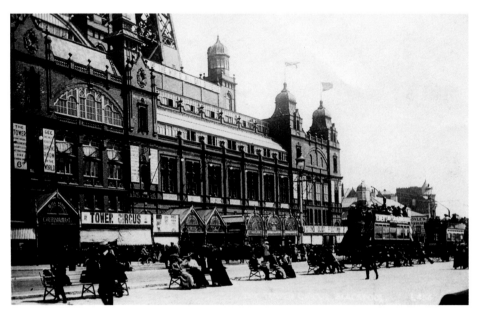

SECTION 2

BLACKPOOL TOWER, THE PALACE, THE WINTER GARDENS AND THE BIG WHEEL

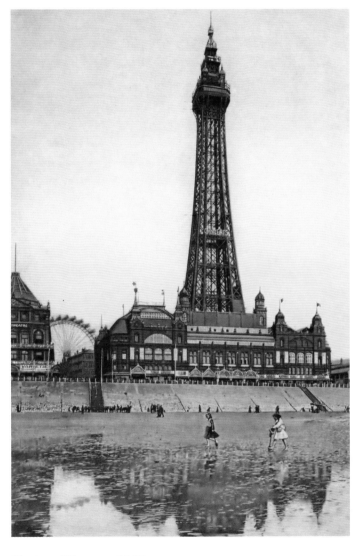

Blackpool Tower *c.* 1905.

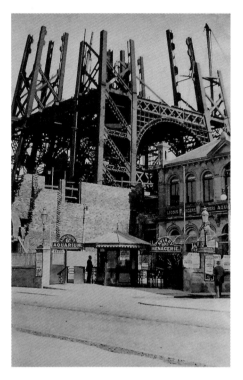

Blackpool Tower I

Work on the foundations for Blackpool Tower started in 1891 on the promenade frontage between Victoria Street and Heywood Street where Sir Benjamin Heywood's house West Hey had resided before being converted into the Prince of Wales Arcade (1867) and before Dr Cocker's Aquarium, menagerie and aviary buildings were added. The picture (left) is from 1893 when construction was at approximately 85 feet. The Aquarium wing, to the south of the tower structure, was later incorporated into the main building but remained in use while the Tower was erected to help bring in revenue. Below is a view of the Tower from Central Beach with construction works progressing in 1893 to approximately 150 feet.

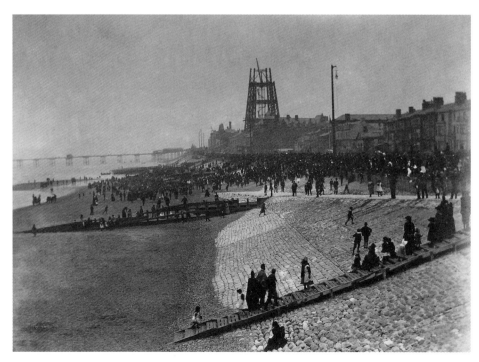

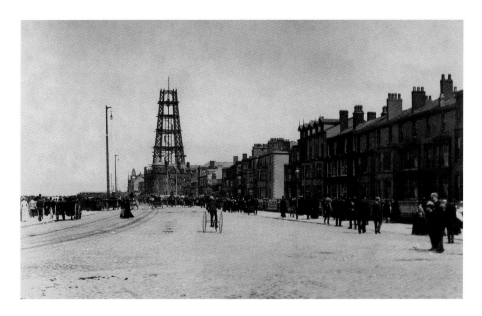

Blackpool Tower II

The picture above of the Tower is taken from the centre of an almost 'traffic-less' promenade near Chapel Street when the Tower construction works had reached almost 250 feet. The Promenade properties to the right still have their gardens and are yet to be taken over by the entrepreneurs who would later create 'The Golden Mile'. The picture below shows the construction of the Tower when it had reached the floor of the upper observation platform level (approximately 390 feet) in the summer of 1893. The works to the Tower's structure were completed in late 1893 with works to finish the building on-going in time for its opening on Whit Monday 14 May 1894.

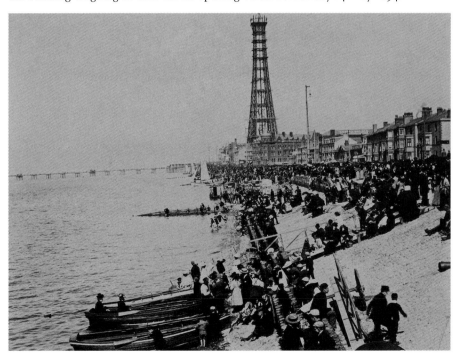

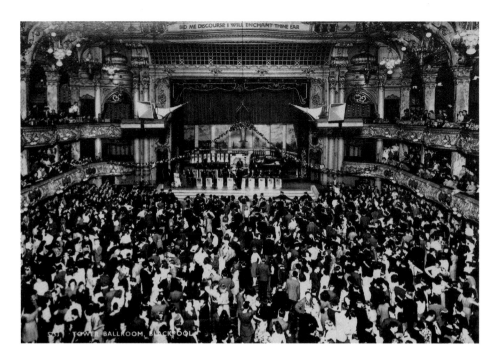

Dancing at the Tower

Dancing at the Tower was originally held in the Grand Pavilion, but, due to the lavishness of the Winter Gardens' Empress Ballroom (1896), John Bickerstaffe engaged Frank Matcham (Grand Theatre architect) to transform it into one of the finest in the country. The sumptuous Louis XV-style Tower Ballroom opened in 1899. The view above shows a typical packed dance floor in the late 1940s. Reginald Dixon MBE (below) was the resident organist at the Tower Wurlitzer from March 1930 to March 1970. Reginald was famous for his signature tune 'I Do like to be Beside the Seaside' who broadcast many times live on the radio and was a top-selling artist of his time.

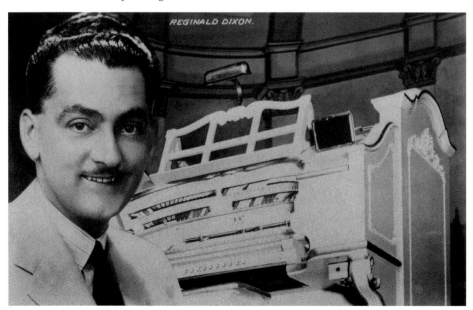

Inside the Tower I

Lavish and spectacular children's ballet shows at the tower started in the 1902 season and were under the direction of Madame Pauline Rivers for the first thirty-two years. Auditions were held and a dance company formed comprising some 150 local children. Each season's ballet always had a current theme and a century ago the 1915 theme was the patriotic 'Grand Spectacular Ballet – For Love of Mother Country'. The Tower Café Restaurant (below) was a first-class restaurant situated below the ballroom. The 1936 season souvenir programme states that Florenze and her Romany Band were playing there and that 'theatre suppers were a speciality'.

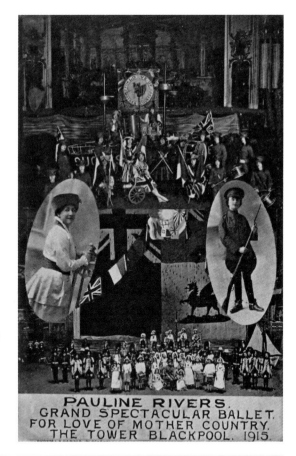

PAULINE RIVERS.
GRAND SPECTACULAR BALLET.
FOR LOVE OF MOTHER COUNTRY.
THE TOWER BLACKPOOL. 1915.

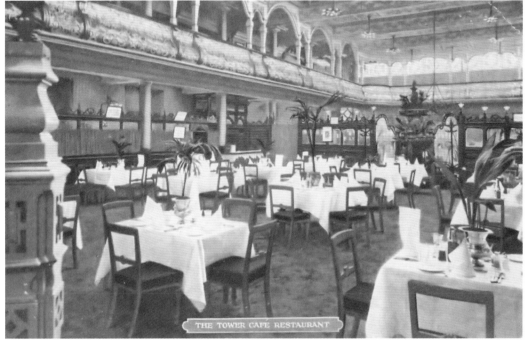

THE TOWER CAFÉ RESTAURANT

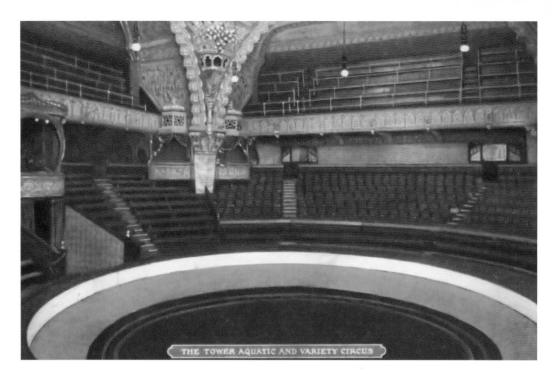

THE TOWER AQUATIC AND VARIETY CIRCUS

Inside the Tower II

The Tower Circus is located at the base of the Tower, between its four legs. The Circus opened on 14 May 1894 and, like the ballroom, its Moorish-style interior was designed by Frank Matcham, in 1900. The floor to the ring can be lowered and flooded with water for spectacular water finales. Charlie Cairoli (below) was born in Milan on 15 February 1910 and is arguably the greatest clown to have appeared at the Tower Circus. He appeared from 1939 until retiring in 1979. The 1949 postcard shows Charlie and his trademark red nose and bowler hat with his assistant Paul Freeman, a white-faced clown and brilliant musician.

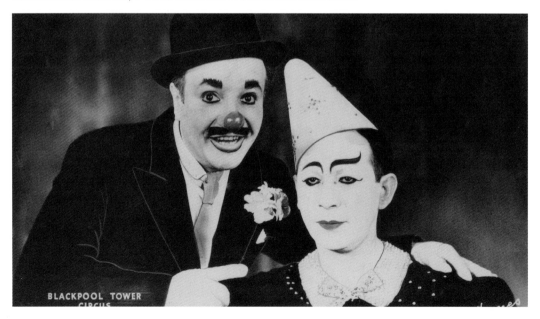

BLACKPOOL TOWER
CIRCUS

The Tower Circus

The Tower Circus originally advertised itself
as 'The Tower Aquatic and Variety Circus'
and routinely included animal acts until 1990,
with lions; elephants that either balanced
on one leg, put their feet on each other's
backs or were ridden by showgirls; cheeky
chimpanzees; sea lions performing with
balls; polar bears on scooters; Indian bulls;
horses and dogs. The postcard view below is
advertising Madame Emmy Truzzi and her
performing-horse equestrian act and shows
them exercising on Central Beach. Madame
Truzzi regularly appeared in circuses in the
1940s and 1950s with her 'talented dogs' and
a pony.

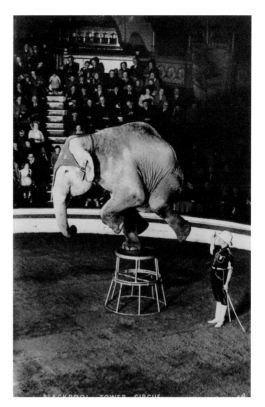

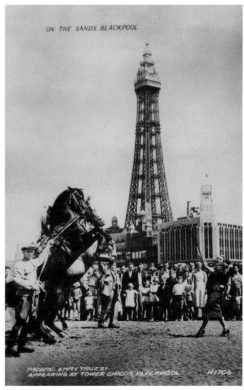

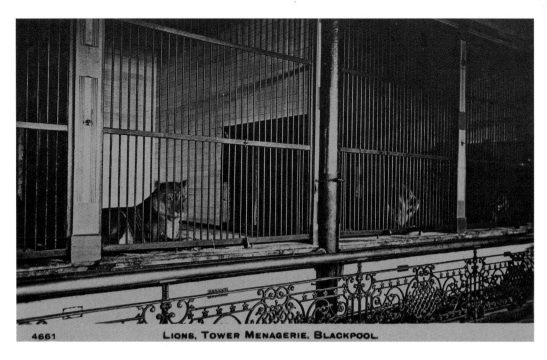

4661 LIONS. TOWER MENAGERIE. BLACKPOOL.

The Tower Zoo

A menagerie had originally formed part of Dr Cocker's attractions on the site from 1873 and was incorporated into the second floor of the Tower in 1894. The Tower Zoo kept lions, tigers, polar bears, small mammals and tropical birds. The menagerie that can be seen in the photographs was replaced by the Ocean Room in 1963; however, one in the Roof Gardens had opened in 1956 and lasted until 1977. You could get quite close to the animals in their small cages, but it is difficult to see how Albert got pulled into a cage and swallowed 'whole' by the 'great big lion called Wallace'.

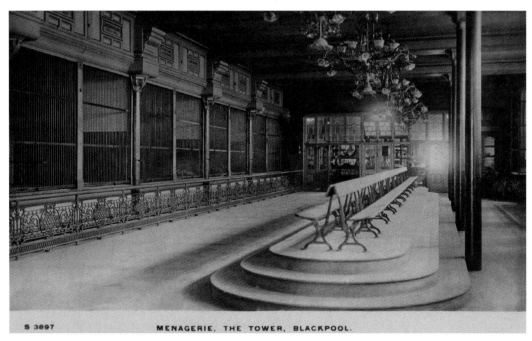

S 3897 MENAGERIE, THE TOWER, BLACKPOOL.

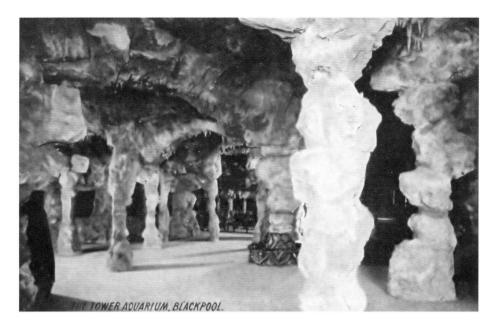

TOWER AQUARIUM, BLACKPOOL.

The Aquarium and Roof Gardens

An aquarium was also previously part of Dr Cocker's attractions from 1873 and formed a great attraction. It continued on the ground-floor of the Tower when it opened in 1894. It is said to have been re-modelled on the limestone caverns in Derbyshire and the postcard view above shows its 'cave-like' interior from around 1909. The aquarium closed in 2010 and the fish were moved to the nearby Sea Life Centre. The space is now occupied by the Blackpool Tower Dungeon. The Roof Gardens (below) housed exotic palms and ferns and was a haven of tranquillity with seating and a stage for concerts at one end. The area now houses Jungle Jim's children's indoor adventure playground.

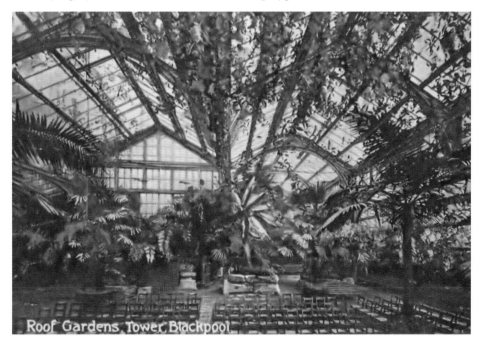

Roof Gardens Tower, Blackpool.

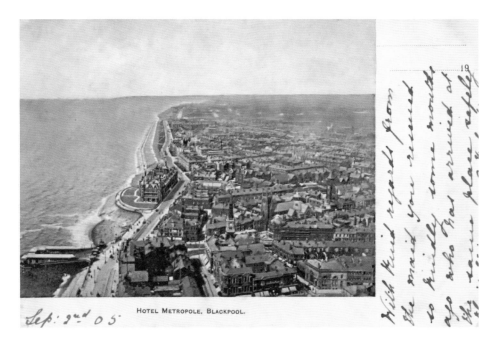

HOTEL METROPOLE, BLACKPOOL.

Sep: 2nd 05

With kind regards from the maid you received so kindly some month ago who had arrived at the same place, reply...

A Bird's Eye View

The early undivided back postcard view above, looking north from the top of the Tower and dated 2 September 1905, appears to have been sent by a maid who was probably working at the Metropole Hotel. The early 1900s Tower top view shows the expanding area of the town together with the newly built Town Hall and its spire in the bottom centre. Work to build Princess Parade did not start until 1909. The fine 1920s view below from the Tower top looking east also shows the spread of housing together with St John's Church to the left and the Winter Gardens complex and the relatively diminutive Big Wheel.

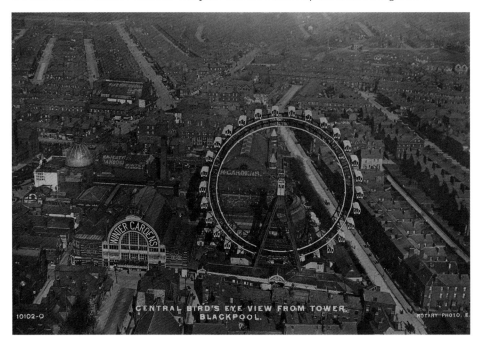

10102-0 CENTRAL BIRD'S EYE VIEW FROM TOWER, BLACKPOOL. ROTARY PHOTO, E.

30

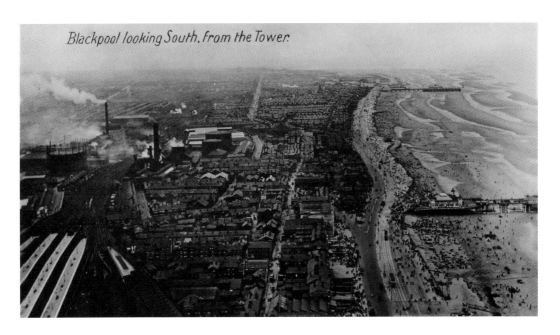

Blackpool looking South, from the Tower.

Blackpool from Above

The view looking south from the Tower top in the early 1930s is somewhat more industrial than the views on the opposite page. To the left are the excursion platforms of Central Station and the Gas Works chimneys and gas holders adjacent to Rigby Road. Just behind the Promenade runs Bonny Street and in the distance Lytham Road runs towards Blackpool's southern boundary at Squires Gate. Aerial views of the Promenade (below) were ever popular and this 1948 view shows the Palace, the Tower, Woolworth's and the Palatine Hotel. To the left, the Odeon Building (1939) can be seen and further on is the Water Tower (1932) on Leys Road near Warbreck Hill.

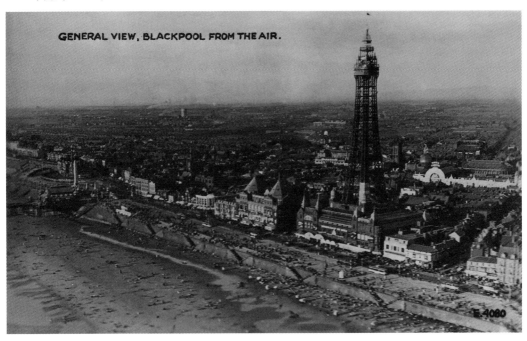

GENERAL VIEW, BLACKPOOL FROM THE AIR.

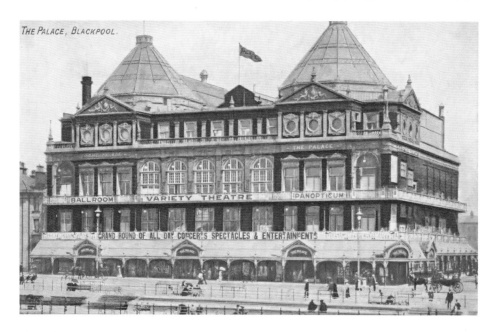

The Palace I

Originally opened in July 1899 on the site of the Prince of Wales Theatre and Hall of Aquatic Entertainment, The Alhambra boasted a 1,200-seat circus, a 3,000-seat variety theatre and a 3,000-capacity ballroom. However, it was not a success and it was purchased in 1903 by the Blackpool Tower Company, re-opening in 1904 as The Palace: 'The People's Popular Palace of Pleasure'. The building's interior was re-designed by Frank Matcham and its former circus is seen below as the ballroom in a 1907 postcard view. The Palace was demolished in 1962 and Lewis's department store with its unusual honeycombed façade opened in 1964, closing in 1993.

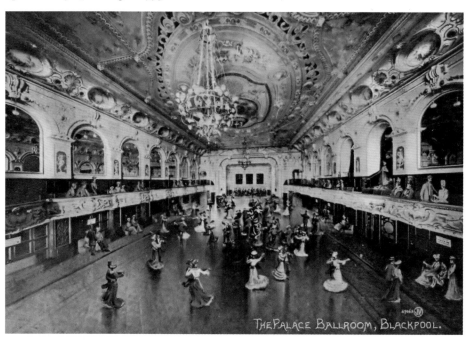

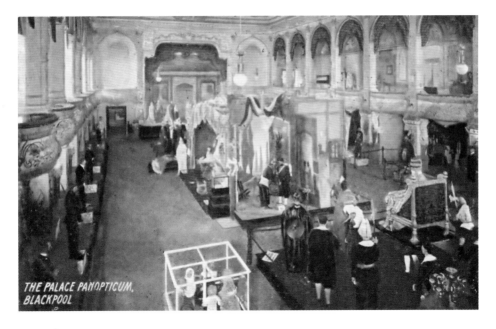

THE PALACE PANOPTICUM. BLACKPOOL

The Palace II

For its re-opening in 1904 the Blackpool Tower Company converted the Alhambra's Ballroom into the Palace Panopticum. As can be seen from the 1907 postcard view the Panopticum comprised groups of historical figures rather like a 'waxworks' exhibition. It was converted back to a ballroom in 1911 and remained as such until its closure in 1962. The interior of the Alhambra was in the Italian Renaissance style and was described by Arthur Lloyd as being 'as lavish as the and Winter Gardens Complexes, with Italian marble and Venetian mosaic floors, walls lined with marble from Italy and Belgium, glittering mirrors, allegorical paintings, and ornate plasterwork'. The Palace Italian Lounge is seen below around 1924.

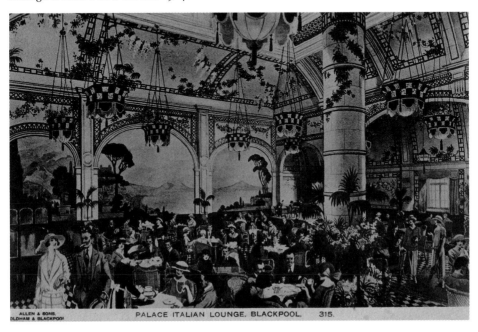

ALLEN & SONS. OLDHAM & BLACKPOOL PALACE ITALIAN LOUNGE. BLACKPOOL. 315.

Winter Gardens Church Street entrance from Abingdon Street *c.* 1905.

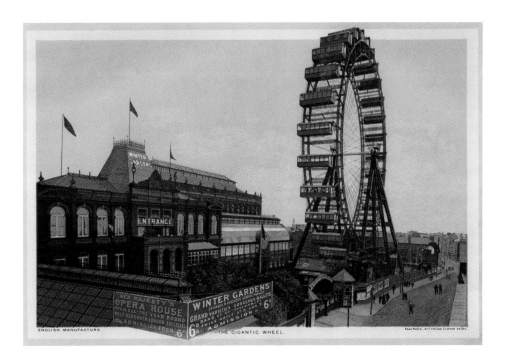

The Winter Gardens I

The Winter Gardens buildings were constructed on the site of Bank Hey, home of Blackpool's first Mayor, Dr W. H. Cocker, from 1875. An open-air skating rink was completed in 1876 and an indoor rink in 1877 and this was followed by the opening of the Church Street entrance, its 120-feet-high circular glass dome with twelve classical statues around the base, the Grand Pavilion, Vestibule and Floral Hall in June 1878. The view above is looking down Coronation Street from Church Street and shows the 'Grand Vestibule' entrance to Winter Gardens to the left and the Big Wheel. The grandeur of the entrance to the Floral Hall can be seen in the 1930s postcard view below.

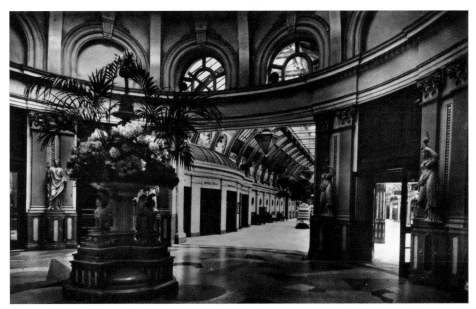

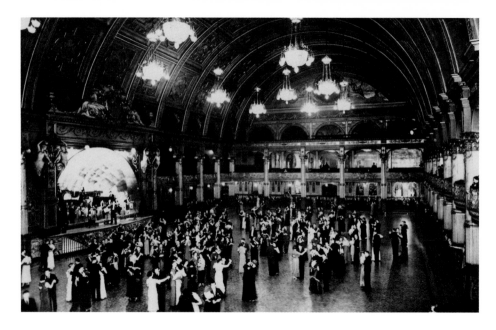

The Winter Gardens II

To compete with the Tower, the Winter Gardens Co. opened the Empress Ballroom in 1896 after a covenant restricting dancing was removed. It has hosted various events and competitions such as the Blackpool Dance Festival from 1920, political conferences, darts competitions and musical concerts including the Rolling Stones (1964), Queen's first headlining tour (1 March 1974) and the Kaiser Chiefs (2012). The richly decorated, Raj-inspired Indian Lounge adjoining the Empress Ballroom is seen below in the 1905 postcard view. It was opened in August 1896 and was principally used as a reception room, although instrumental concerts were given during the season.

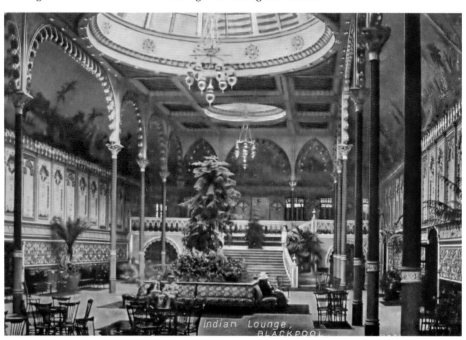

Indian Lounge, BLACKPOOL

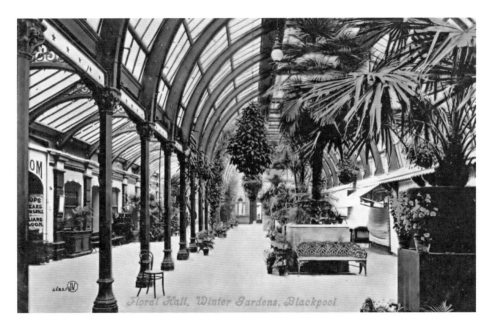

Floral Hall, Winter Gardens, Blackpool

The Winter Gardens III

The elegant Floral Hall is the main passageway through the Winter Gardens and from its Church Street entrance access can be gained to the Opera House, Empress Ballroom and the Coronation Street entrance. The Floral Hall, with its curved glass and steel roof, opened in 1878 and was resplendent with its statues, exotic palms, tree ferns and flowering plants. It was refurbished in 2011. The imposing glass arched 'Winter Gardens' Coronation Street entrance (right) was completed in 1897 and was strategically placed at the top of Victoria Street to attract visitors away from the promenade and the Tower. The arch was clad in white faience in 1930 when the Olympia was built.

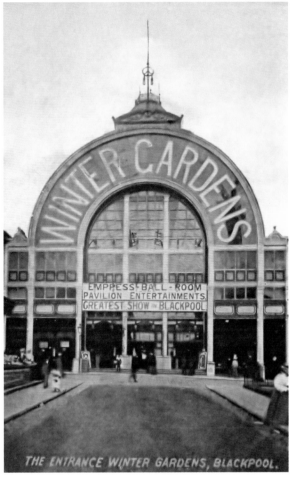

THE ENTRANCE WINTER GARDENS, BLACKPOOL.

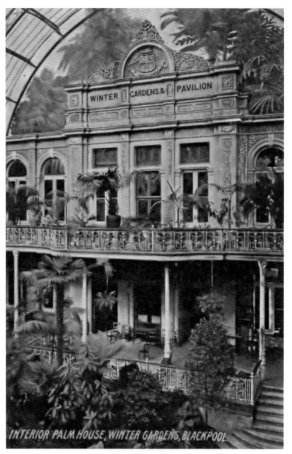

INTERIOR PALM HOUSE, WINTER GARDENS, BLACKPOOL.

Inside the Winter Gardens

The postcard view to the left (*c.* 1910) shows the interior of the entrance from Coronation Street with its glass arch abutting onto the front of the former entrance hall. This entrance area originally formed a large peaceful 'Palm House' with paths, planted rockeries, seats and statues. The Spanish Hall (Spanish Court Yard), seen below, was opened in 1931 after the Winter Gardens had been acquired by the Tower Company in 1928. A mezzanine floor was created in the Coronation Street Palm House area and an unusual and inspired Spanish Hall with Andalusian village representations in the corners was created by art director Andrew Mazzei.

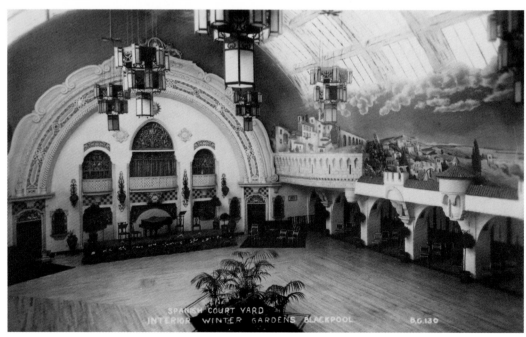

SPANISH COURT YARD
INTERIOR WINTER GARDENS BLACKPOOL

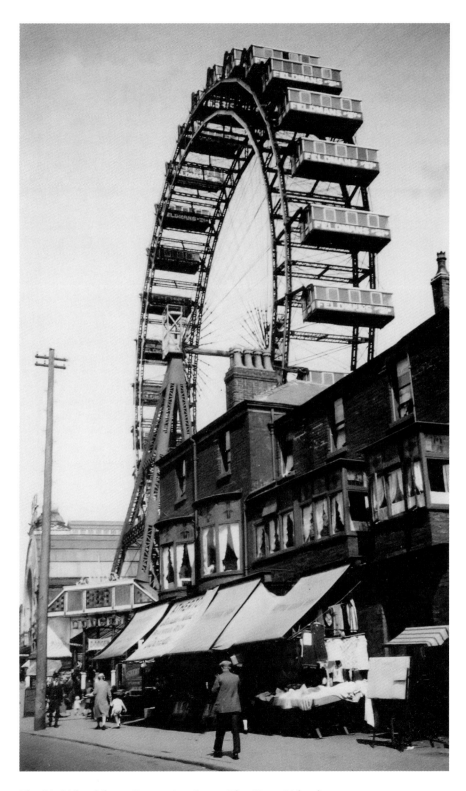

The Big Wheel from Coronation Street, The Great Wheel.

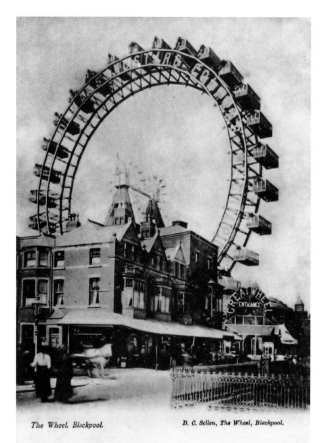

The Great Wheel

The Great Wheel was built by 'the Blackpool Gigantic Wheel Co.' and opened on 22 August 1896. It was 220-feet high, with thirty carriages, each able to carry thirty people. For the fare of 6d the wheel rotated once, taking over fifteen minutes. In the first season it carried 221,000 passengers, a third of the expected number. In the next season the fare was reduced to 3d and while the number of passengers increased to 298,000, the receipts dropped. Blackpool Tower Co. took over the Winter Gardens in February 1928 and the last 'trip' on the Wheel is said to have been by the demolition contractor and his family on 28 October 1928. The Olympia opened on the site in 1930.

The Wheel. Blackpool. *D. C. Sellen, The Wheel, Blackpool.*

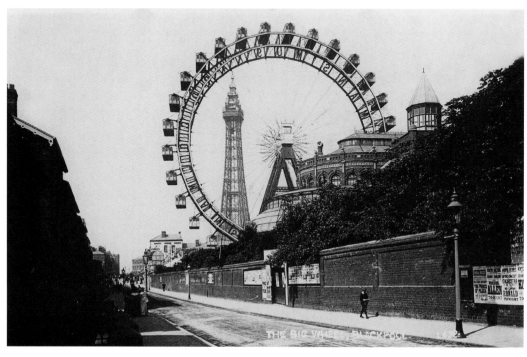

THE BIG WHEEL, BLACKPOOL.

THE THREE PIERS AND THE PLEASURE BEACH

The Three Piers – artistic licence.

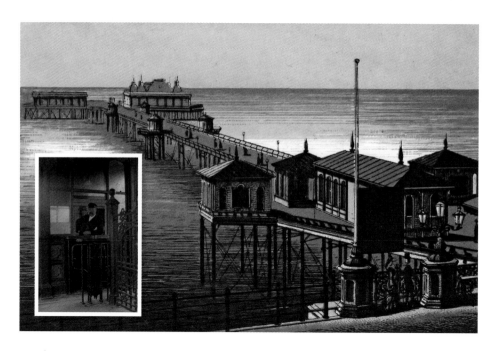

North Pier I

North Pier (1862–63) was designed by Eugenius Birch for the Blackpool Pier Co. and was constructed by R. Laidlaw and Sons of Glasgow at a cost of £11,500. It had a grand opening on 21 May 1863. The pier is seen above around 1890, together with the inset view of the tool booth and its attendant who collected the 2*d* admission charge. A jetty was built between 1864–67 and was later used to operate pleasure steamers. A new entrance was built in 1869 and the pier was widened to forty-eight feet in 1897. The Indian Pavilion opened at the seaward end of the pier in 1877 but was destroyed by fire in 1921.

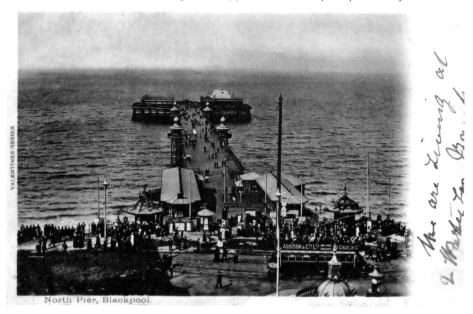

North Pier, Blackpool

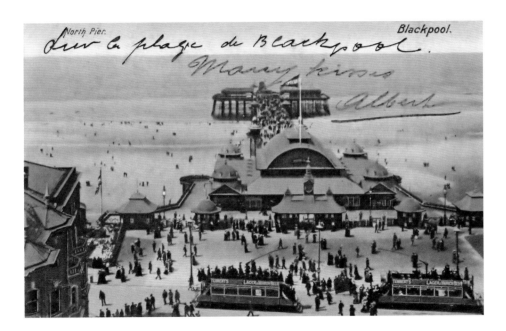

Sur la plage de Blackpool.
Many kisses
Albert

North Pier II

The view of North Pier was taken from the roof of Yates's Wine Lodge and was posted to France on 22 February 1904. It shows the newly finished eastern-style pavilion at the landward end of North Pier, where vocal and orchestral concerts were given. There are two Dreadnought trams in Talbot Square. The Merrie England Bar (below) was opened in the 1960s and was re-developed in the early 1980s. Today it is marketed as a fun and party destination with comedy shows. North Pier was given a neo-Victorian façade in the 1980s after the pier was purchased by Lord Delfont's, First Leisure Co. and has been owned by the local Sedgwick family since April 2011.

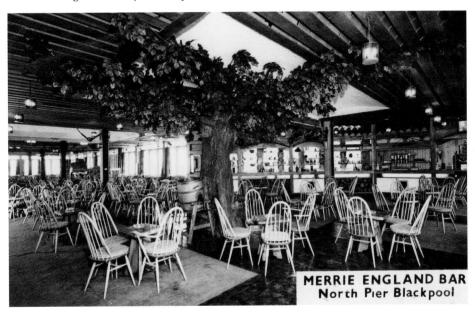

MERRIE ENGLAND BAR
North Pier Blackpool

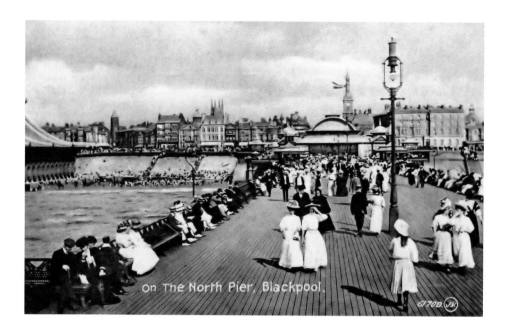

North Pier III

The development of seaside piers in the first half of the nineteenth century introduced the possibility of safe 'promenading' over the water and the postcard views on this page both show the popularity of 'strolling' on North Pier around 1908. The postcard view above looks back towards Talbot Square, the Town Hall with its spire and the Clifton Hotel. The postcard view below is one of the most popular postcard views and is taken from the theatre at the end of the pier and looks back at the promenade and sea wall south of North Pier as well as showing the Big Wheel, the Palace and the Tower.

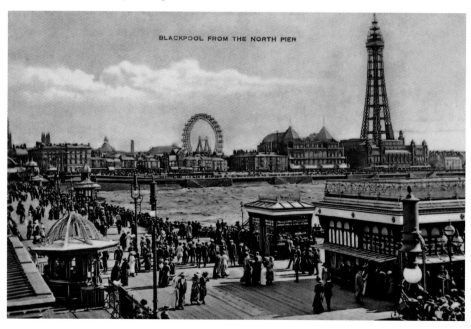

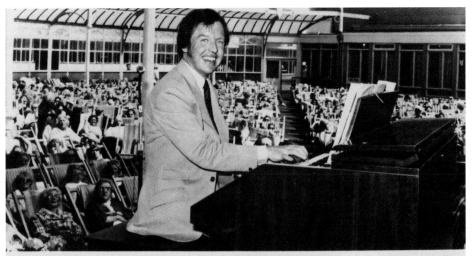

Raymond Wallbank
Sun Lounge • North Pier • Blackpool

North Pier IV

Raymond Wallbank (1932–2010) was educated at King Edward VII School, Lytham and was an accomplished performer, composer and arranger. He was the resident (Wurlitzer) organist at the North Pier Sun Lounge from 1965 to 1995 and was dubbed the 'Prince of North Pier' by Lord Delfont. The postcard above from the early 1970s invites the reader to 'Relax and listen to Raymond Wallbank at the Organ. LP now available price 73p'. The aerial view of North Pier (c. 1962), with the tide in, shows part of the jetty, the theatre and sun lounge at the seaward end and the mass of deck-chair-seated holiday-makers along the length of the pier.

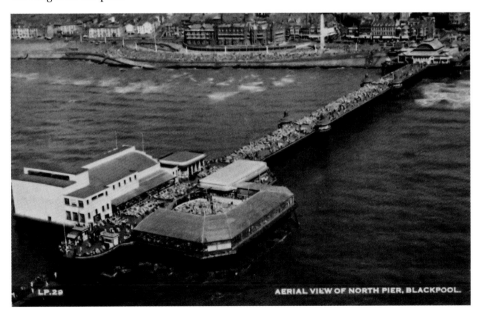

LP.29 AERIAL VIEW OF NORTH PIER, BLACKPOOL.

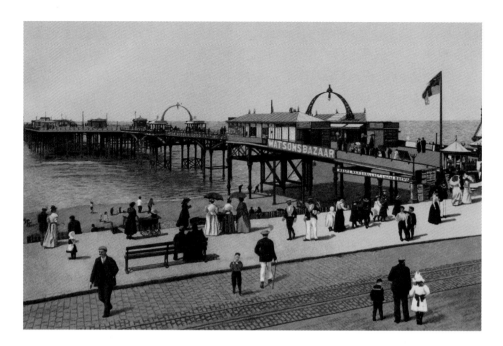

Central Pier I

Originally named South Pier, work on a second Blackpool pier started in 1867 and the pier was opened on 30 May 1868, at a cost of £10,000. The pier was not an instant success but after Bob Bickerstaffe took over the management of the pier in 1870 he organised steamer excursions to Southport and open-air dancing on the pier to German bands (Quadrille bands) and later military bands. The pier became known as the People's Pier and changed its name to Central Pier in 1893 when Victoria Pier opened. The postcard below shows dancing on Central Pier around 1907.

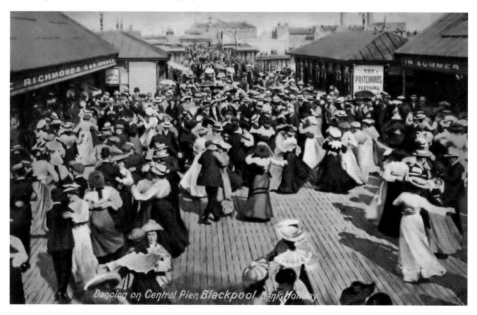

Dancing on Central Pier, Blackpool. Bank Holiday.

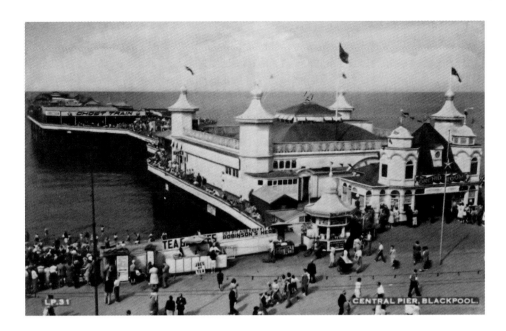

Central Pier II

The White Pavilion at the landward end of Central Pier was built in 1903 and is seen above in a 1961 postcard. It was demolished in 1967 to make way for the Dixieland Palace which opened in 1968. 'Uncle' Peter Webster hosted children's shows and talent competitions at the pier from 1951 and played to packed audiences in the open air and the theatre. He retired in 1982. After First Leisure took over the pier in 1983, the Dixieland Palace was changed to Maggie May's in 1986 (later Peggy Sue's Showboat) with Linda Nolan playing Maggie May for over ten years. A 33-metre high Ferris wheel opened on the pier on Good Friday 1990, at £1.00 a ride.

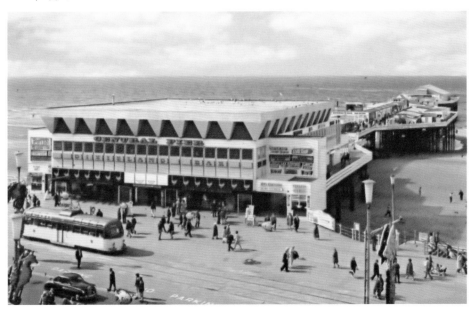

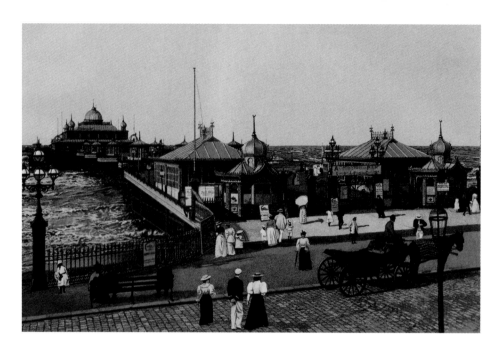

Victoria Pier I

Victoria Pier opened on Good Friday, 31 March 1893, with the 'up-market' Grand Pavilion opening on 20 May 1893 at its seaward end. The Grand Pavilion hosted brass band and classical concerts and Edward de Jong was the first musical director. The pier is seen in the album view above around 1900 before the promenade was widened in 1902 and the pier frontage set back. The pier's 1911 front pavilion (below) has changed several times over the years to the Regal Theatre (1937), to the Beachcomber amusement arcade in 1962, later to a circus-style frontage and now a plainer frontage.

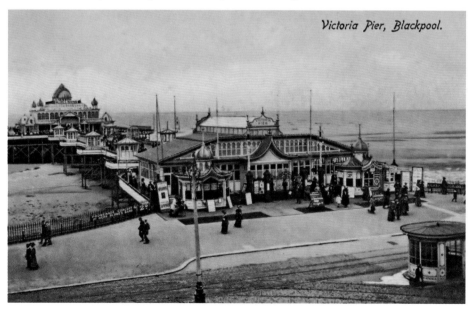

Victoria Pier, Blackpool.

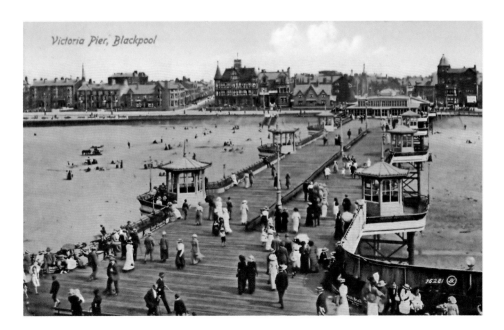

Victoria Pier II

Victoria Pier was wider than North or Central Piers and is said to have had thirty-six shops and shelters. Today the area of the pier in the postcard view above is fully occupied with buildings, housing stalls and amusements. The pier-head theatre was demolished in 1998 and is now packed with children's and 'white knuckle' rides. To the left of the mid-1950s postcard below is the Regal Theatre at the landward end of South Pier. A Railcoach tramcar is approaching the Open Air Baths stop and, while there are quite a few people on this part of the promenade, there are very few cars.

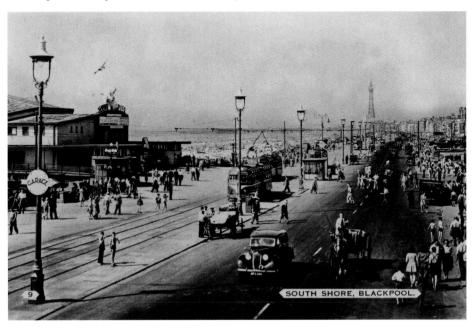

SOUTH SHORE, BLACKPOOL.

49

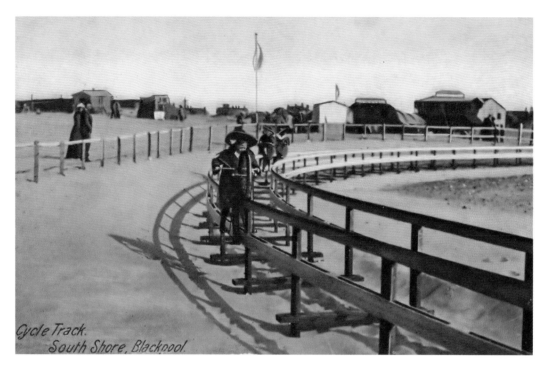

Cycle Track.
South Shore, Blackpool.

South Shore

Fairground-type attractions were present on land adjacent to (and on) South Shore beach in the 1890s and William George Bean and John Outhwaite purchased land there and founded Blackpool Pleasure Beach in 1904. The view above shows the Hotchkiss bicycle railway, for which Bean had the European rights, introduced in 1896. The postcard below, posted in 1905, shows the 'Aerial Flight' zip-wire ride on the beach.

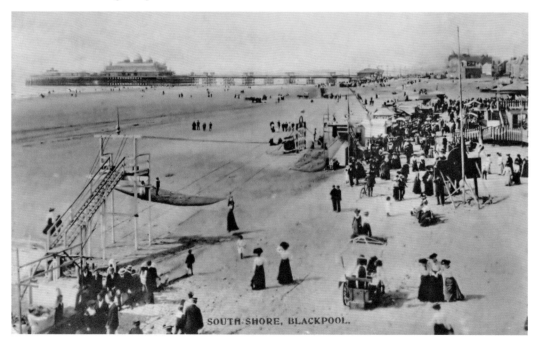

SOUTH SHORE, BLACKPOOL.

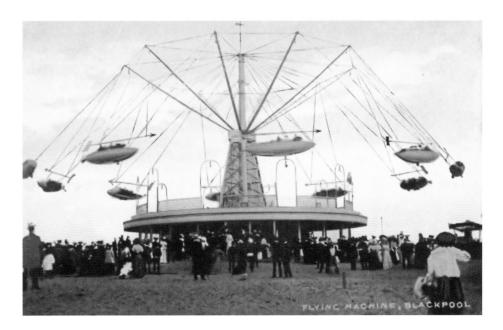

Pleasure Beach I

The first major attraction at the Pleasure Beach was Sir Hiram Maxim's Flying Machine (1 August 1904) with its ten gondolas, each 6 metres long and able to carry four passengers, seen above in a 1905 postcard view. Sir Hiram (famous for his machine gun) developed the ride to give the public the sensation of flying. The ride has remained unchanged except for the restyling/re-branding of the cars over the years, which are currently styled as 'Pleasure Beach Airlines' rockets. The casino (below) was built in 1913 at the entrance to the park but was demolished in 1937 and replaced by the art deco circular casino designed by architect Joseph Emberton. The promenade from South Pier to Starr Gate was created between 1922–26.

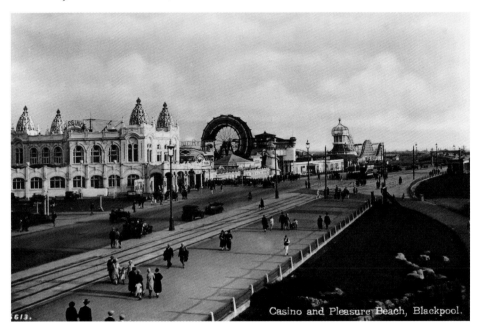

Casino and Pleasure Beach, Blackpool.

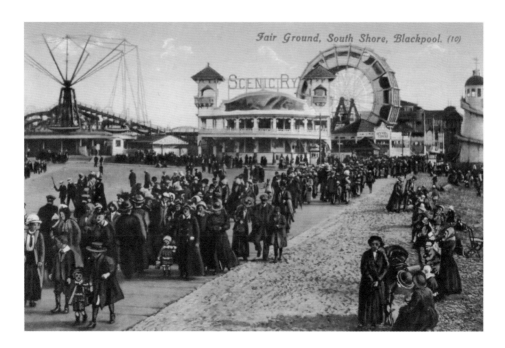

Fair Ground, South Shore, Blackpool. (10)

Pleasure Beach II

The developing Pleasure Beach is captured above with the Scenic Railway (1907), a mile-long wooden coaster ride going around the track twice, in the centre. Behind is the Rainbow Wheel (1912) and the River Caves (1905) and to the right is the Helter Skelter (1905). The sign for the Dodgems (1921), below, states 'The First in Europe – Direct from America'. The Rainbow Wheel is described in a brochure as a 'Great Wheel with two humped railways within the periphery which is prismatically painted to represent the rainbow. The giant circle revolves. The passengers are carried part the way round, until the cars, by gravitation, run over the humps and up the other side of the Wheel and then they roll back'.

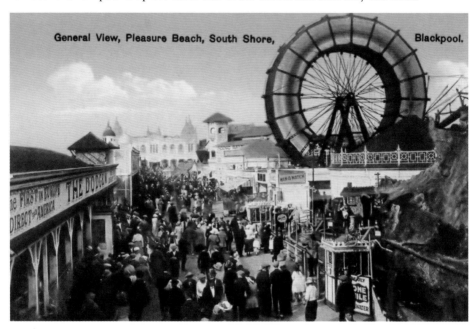

General View, Pleasure Beach, South Shore, Blackpool.

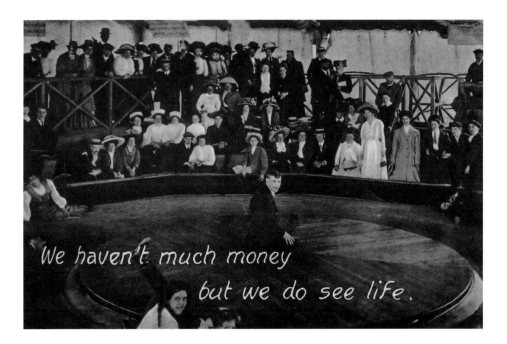

We haven't much money but we do see life.

Pleasure Beach III

The Joy Wheel, above, was a popular ride (1910–37) and comprised a low quickly spinning disc where visitors attempted to defy the centrifugal forces acting upon them. One man appears to have found a way to stay on by sitting exactly in the centre. The Water Chute (1907–1932), below, was based upon a water chute attraction at the Earls Court Exhibition in London and was 65 feet high and had a 267-feet incline into the lake at the bottom. It could release fifty-five boats an hour at 3*d* a ride, each controlled by a gondolier standing upright in the boat and landing his passengers on a bank.

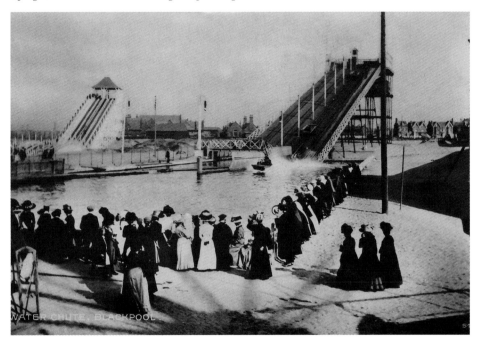

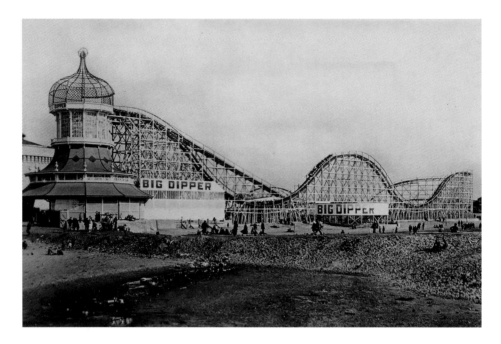

Pleasure Beach IV

The original Big Dipper (above) is a two-train wooden roller coaster which opened in 1923 in an L-shaped layout along the beach frontage and its southern boundary. It was re-designed and extended in 1936 to compete with the more exciting Grand National coaster ride which had opened in 1935. The early aerial view below of the Pleasure Beach dates from 1920 and shows the Switchback Railway along the beach to the left. The large circular building is the Naval Spectatorium (1910) in which (cardboard and smoke) re-enactments were shown of the American Civil War battle between the ironclads *Monitor* and *Merrimac*.

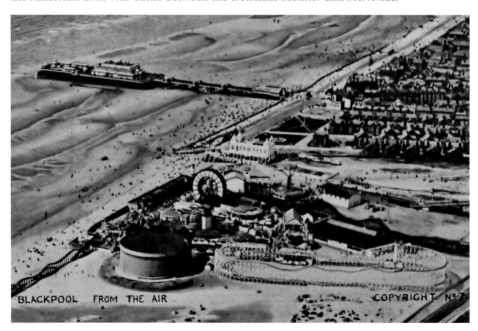

Section 4

HOTELS, BOARDING HOUSES, COMIC, SAUCY AND THE ILLUMINATIONS

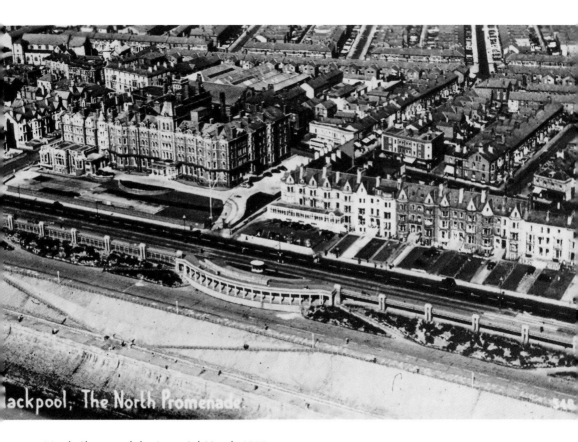

Blackpool, The North Promenade

North Shore and the Imperial Hotel, 1953.

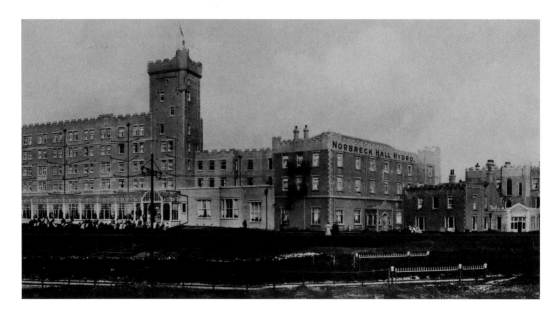

Norbreck Hydro

The development of the Norbreck Hydro Hotel from Norbreck Villa commenced around 1900 by J. Shorrocks. In the centre of this 1913 postcard, the small wing (with the Norbreck Hall Hydro sign) was added in 1905 and the large wing to the left was added in 1912. A new wing was opened in the 1930s. In 1936 the hotel advertised itself as the 'greatest recreative hydro in the world' and stated it had an eighteen-hole golf course, twenty-three tennis courts, cinema/ballroom, gymnasium and warm indoor sea-water swimming baths. By 1971 it had 326 bedrooms, 'many with private bathrooms' and the daily (bed and breakfast) tariff was £3.25.

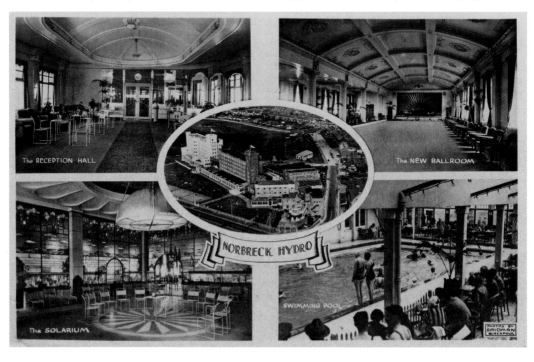

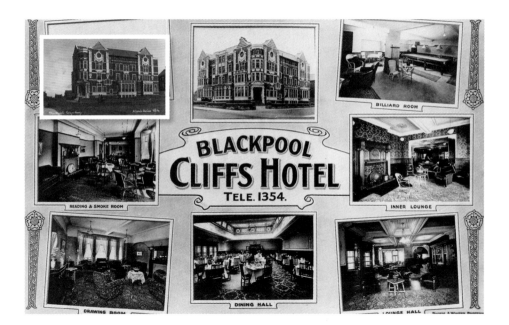

Blackpool Hotels I

The Cliffs Hotel on Queen's Promenade, North Shore, was originally the Bryn Tivy. The 1927 multi-card above shows the hotel when it had been partially extended. The building was fully extended to its present size encompassing the whole block between King Edward Avenue and Empress Drive in 1936–37 and had 240 bedrooms in 1959. In 1971 it had 165 bedrooms and bed and breakfast in the summer season cost from £3.25 a day with a 50p supplement for a private bath and toilet. The Savoy Hotel opened in 1915. It was requisitioned by HM Government for nine years and was re-opened after Easter 1949 with over 250 bedrooms. In 1971 its bed and breakfast tariff was £3.75 a day.

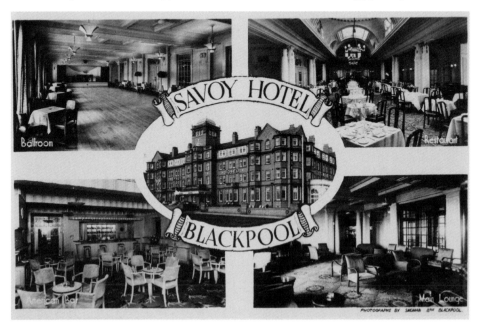

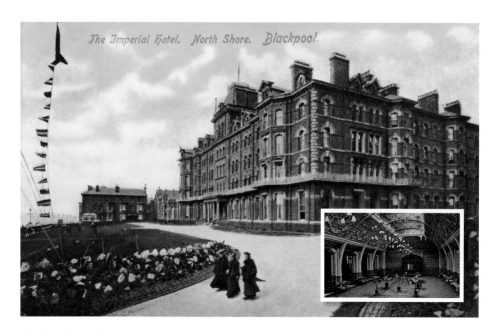

The Imperial Hotel. North Shore. Blackpool.

Blackpool Hotels II

The four star Imperial Hotel is Blackpool's premier hotel. It opened in 1867 on the private 'tolled' frontage of the Claremont Park Estate. It was requisitioned by the government in 1918 and during and after the Second World War. In 1924 it advertised itself as having over 300 bed- and sitting rooms, smoke and billiard rooms, library, recreation room, lounge, Louis XVI Restaurant together with Turkish, Russian and sea-water baths. The Imperial has welcomed HM Queen Elizabeth, Charles Dickens and almost every British prime minister. The hotel below was the Park Hotel from 1894 having previously been the Claremont Hotel. It was re-named the Carlton Hotel in the 1920s. The 1963 postcard shows the hotel with its 1930s art-deco sun-lounge and entrance extension. In 1971 full board was from £4.50 day.

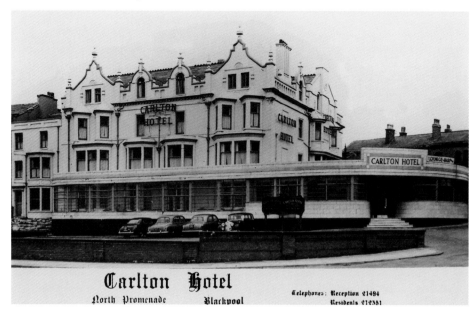

Carlton Hotel
North Promenade Blackpool

Telephones: Reception 21484
Residents 212351

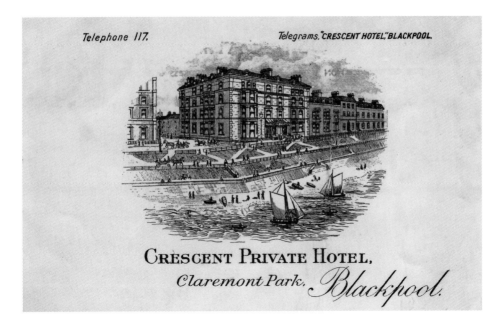

CRESCENT PRIVATE HOTEL,
Claremont Park. *Blackpool.*

Blackpool Hotels III

The Crescent Hotel, North Promenade (1894), on the corner of the road between the Promenade and Dickson Road, where the Claremont Hotel is now located (since 1971), had fifty bedrooms in the 1930s and breakfast, lunch, afternoon tea and dinner cost from 10–6s per day (52½p a day) in 1933. In the late 1950s the Crescent Hotel was at 274–280 North Promenade and had 100 bedrooms. The Metropole Hotel is seen below on its Princess Parade island and was originally Bailey's Hotel (*c.* 1785) with thirty-four bedrooms. It was for many years 'Butlin's by the sea' and hosted Butlin's 'Redcoats', a ballroom and Old Tyme dancing, talent and glamorous grandmother contests.

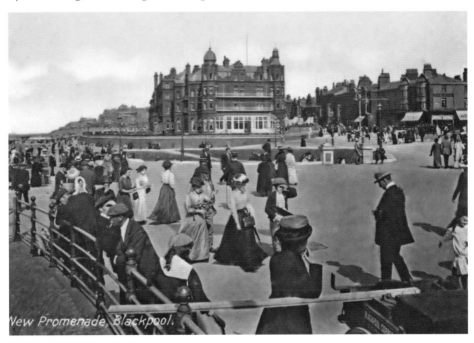

New Promenade, Blackpool.

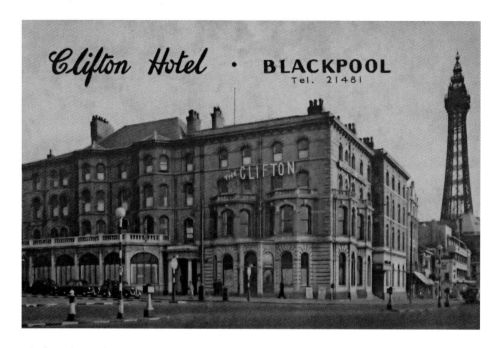

Blackpool Hotels IV

The Clifton Hotel, Talbot Square (seen above in a 1969 postcard) replaced the Clifton Arms Hotel in 1874 (previously Forshaw's) and had over 100 bedrooms. It held the best location, facing the sea opposite North Pier and near to all the major amenities. In 1971 it had ninety-four bedrooms, 'thirty-four with private bath' and bed and breakfast was £2.55 a day. The Brighton Hydro Hotel adjacent Rawcliffe Street, South Shore, is seen below in a 1913 postcard and then had fifty bedrooms, a gentlemen's writing room, a smoke room and ballroom, with a lift to all floors. In 1939 its tariff was 10–6s a day (52½p a day). It is now the Colonial Hotel, advertising rooms at £20.00 per person per day.

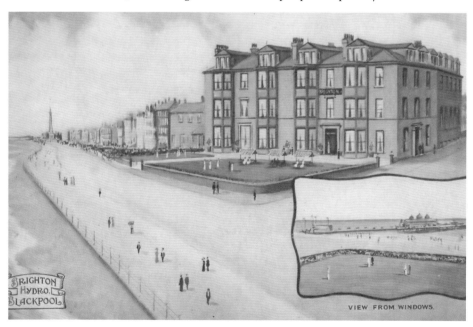

VIEW FROM WINDOWS.

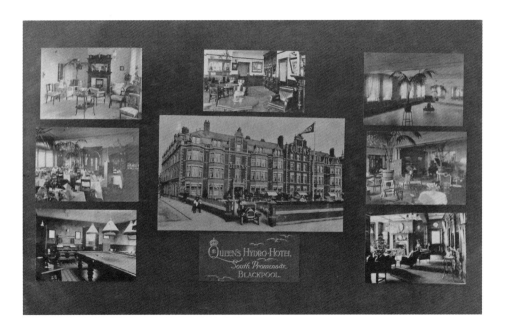

Blackpool Hotels V

The Queen's Hydro Hotel, South Promenade, dates from the late 1890s and in 1935 it advertised a tariff of 14–6s to 17–6s per day (72½p–87½p a day) with 'hot and cold running water in all bedrooms, central heating and bedroom radiators, lift to all floors, permanent first-class orchestra'. It also had a suite of Turkish, Russian and sea-water baths. The Headlands, New South Promenade was built in 1931 and extended in 1933. It advertised itself in 1935 as a 'high-class private hotel' with forty bedrooms with 'Vi-sprung' beds, sea-water baths, a ballroom and electric lift to all floors. By 1959 it had fifty bedrooms, a television lounge, a seventy-foot-vita-glass sun lounge and the daily inclusive tariff was 32s a day.

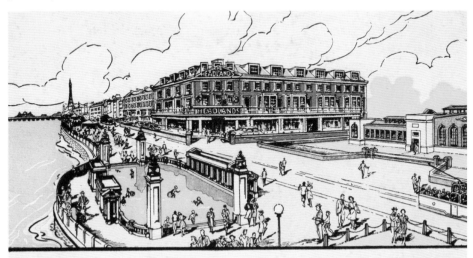

THE HEADLANDS

NEW SOUTH PROMENADE BLACKPOOL S. S.

Telephone: 41179 South Shore Telegrams: HEADLANDS BLACKPOOL

FULLY APPOINTED A.A. and R.A.C. · LICENSED

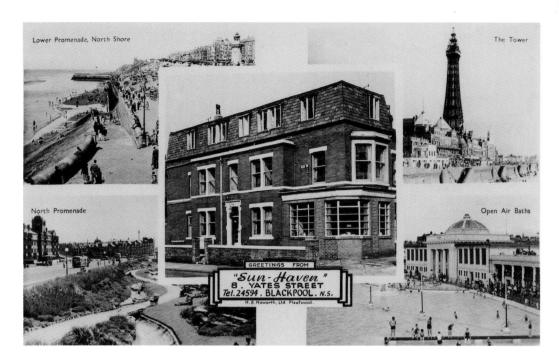

Blackpool Hotels VI

The Sun-Haven Guest House at 8 Yates Street, on the corner of High Street, was like many North Shore guest houses in the 1960s and early 1970s, full in the peak season, often with returning visitors. Now, like many others, it has been converted into self-contained holiday flats. The Amcott private hotel, No. 5 Banks Street, North Shore is advertised in a 1933 Blackpool holiday journal as a 'boarding establishment' run by Mrs Carr with 'moderate inclusive terms and a sea-view'. It is seen above in the postcard dated May 1955. It was run by Mr and Mrs Hamer in 1949 and is now the Sunset Guest House.

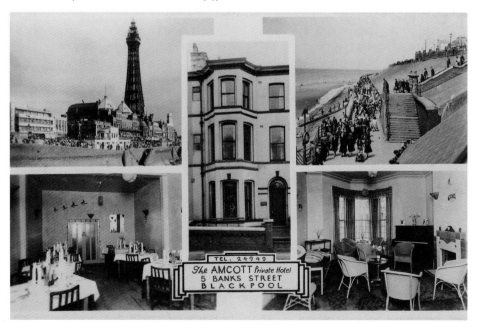

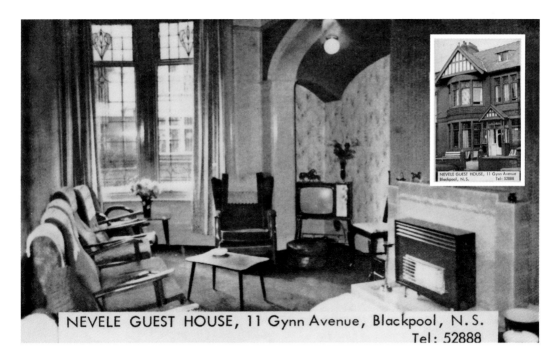

NEVELE GUEST HOUSE, 11 Gynn Avenue, Blackpool, N.S.
Tel: 52888

Blackpool Hotels VII

Nevele Guest House, 11 Gynn Avenue (with inset), was owned by Mr and Mrs Turner in 1959, by Mr and Mrs Kaye in 1964 and by Mr and Mrs Glenn in the early 1970s. The two postcard views are of the Glenn's guest house which is advertised as 'situated in a select part of Blackpool, adjacent Derby Baths, promenade and Gynn Gardens. All bedrooms have H & C water, spring interior beds and razor points. Spacious dining room, separate tables, own keys to bedrooms and front entrance'. Full board was £1.50 a day. Below is Glen Holme guest house, No. 47 Springfield Road with inset of the people staying that week. This property is now the Blackpool Osteopathy Clinic.

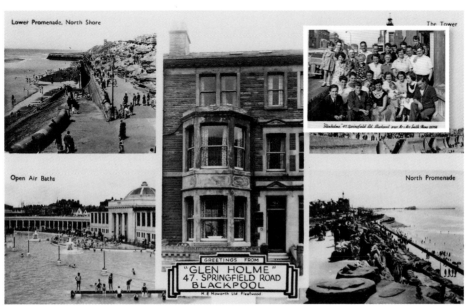

Comic Cards I

Early comic/humorous postcards (pre-1910) were rarely suggestive or offensive and often depicted large portly men, well-proportioned women, ladies enticingly showing their legs below the knee or couples kissing behind an umbrella. These colourful comic postcards were a popular alternative for visitors to Blackpool to send to friends and relatives for their postcard collections to the more traditional views of the Tower, the promenade or the piers. The two postcards on this page date from 1911 and 1908.

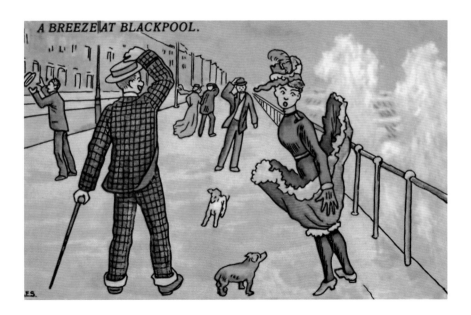

A BREEZE AT BLACKPOOL.

Topographical Cards

Bamforth & Co. made topographical postcards and started producing illustrated 'saucy' postcards in 1910. Sales of Bamforth's cards are said to have reached 16 million in 1963. In the 1950s and 1960s there were concerns over the offensiveness of some cards and in 1954 Donald McGill, the 'king' of saucy postcards and a prolific postcard artist was found guilty of violating obscenity laws. At this time self-appointed postcard censorship committees sprang up around the country including in Blackpool, where the Blackpool Postcard Censorship Board would mark cards 'Approved' or 'Disapproved'. The Blackpool committee closed in 1968. The 1910 card above is re-created in the modern road safety postcard below, illustrated by Mark Fisher for Blackpool Council.

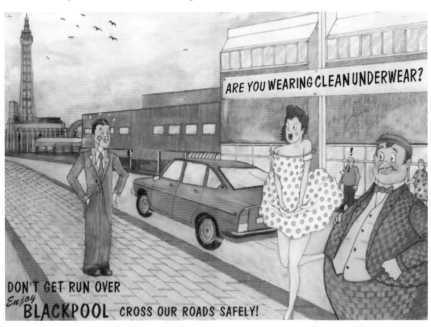

ARE YOU WEARING CLEAN UNDERWEAR?

DON'T GET RUN OVER
Enjoy BLACKPOOL CROSS OUR ROADS SAFELY!

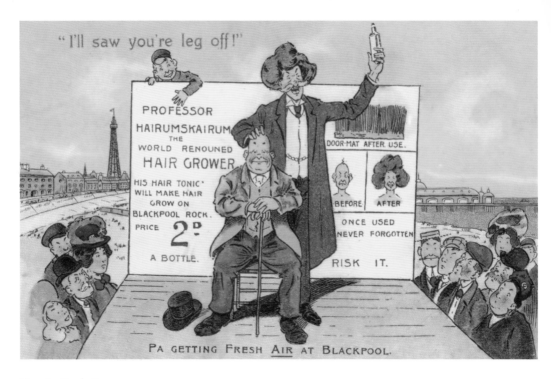

"I'll saw you're leg off!"

PROFESSOR HAIRUMSKAIRUM THE WORLD RENOUNED HAIR GROWER

HIS HAIR TONIC WILL MAKE HAIR GROW ON BLACKPOOL ROCK. PRICE 2D A BOTTLE.

DOOR-MAT AFTER USE.

BEFORE AFTER

ONCE USED NEVER FORGOTTEN

RISK IT.

PA GETTING FRESH AIR AT BLACKPOOL.

Comic Cards II

The two humorous postcards cards on this page fall into the 'novelty' category. The card above is clearly taking a swipe at the bogus selling of alleged hair restorative treatments that were popular at that time. Although a tram conductor was fined in 1886 for overloading his car with thirty-one passengers instead of twenty-two, hopefully the colourful card below was not representative of the last tram from Blackpool in 1907, when it was posted.

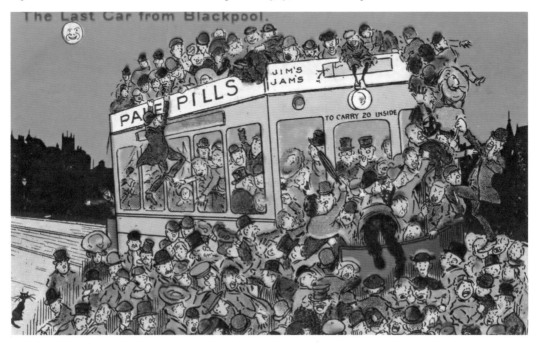

The Last Car from Blackpool.

PALE PILLS

JIM'S JAMS

TO CARRY 20 INSIDE

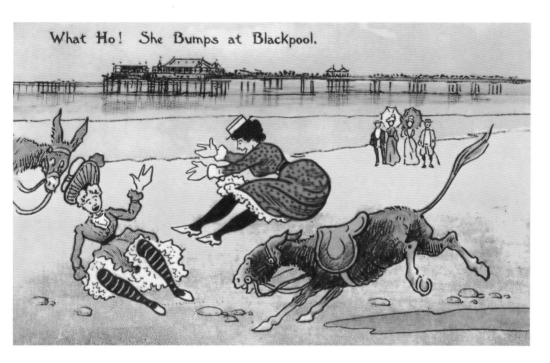

What Ho! She Bumps at Blackpool.

Comic Cards III

The comic postcard above showing two ladies being thrown off donkeys was posted in August 1906 and is indicative of what was thought funny at that time. The stylish postcard below is by the talented artist Lot (Lance) Thackeray who was born in Darlington in 1869 and died in 1916 in Brighton. He worked for Raphael Tuck & Sons of London, producing his first postcard for them in 1900 and was known for his comic sporting illustrations involving billiards and golf and for his many humorous postcards.

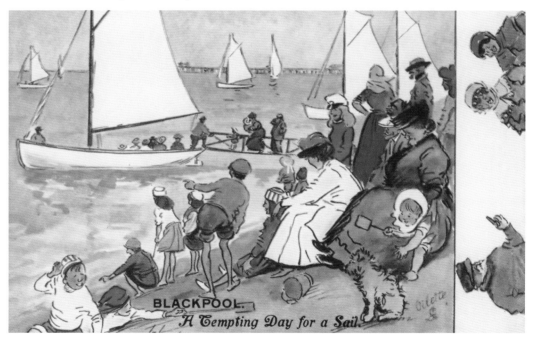

BLACKPOOL. A Tempting Day for a Sail.

The Illuminations I

Blackpool's first electric promenade street lights made an appearance in 1879 and the first illuminated section of the promenade (10,000 lights) was at Princess Parade in May 1912, as part of its opening celebrations. These were so well received that they were repeated in the autumn of 1912 and 1913. They were halted during the 1914–18 war and re-appeared in 1925 on an extended section between Manchester Square to Cocker Square. In 1932 the Illuminations were extended to run six miles from Red Bank Road at Bispham to Starr Gate and animated tableaux were erected along the cliffs from North Shore to Bispham. Seen below are the illuminated gondola, illuminated lifeboat and illuminated standard car outside North Pier.

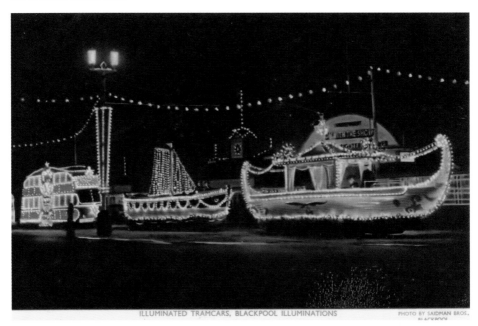

ILLUMINATED TRAMCARS, BLACKPOOL ILLUMINATIONS PHOTO BY SAIDMAN BROS. BLACKPOOL

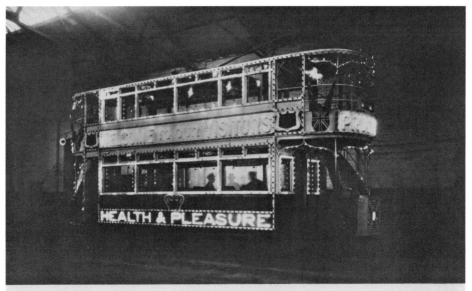

ILLUMINATED CAR. BLACKPOOL.

The Illuminations II

The Illuminations were halted in 1939 on the outbreak of the Second World War and were switched on again in 1949. Often called 'the greatest free show on earth' they have run continuously and developed since then using the most up to date technology. The official 'switch-on' of the lights started in 1934 and many famous people have switched them on, including Stanley Matthews (1951), Red Rum (1977), Les Dawson (1986), and Peter Kay (2014). The first illuminated tramcar was in 1885 and illuminated trams were operated in 1897 for the celebrations of Queen Victoria's Jubilee year. The illuminated Windmill, at its original site (from 1931–63) on top of Manchester Square Pumping Station, is seen below.

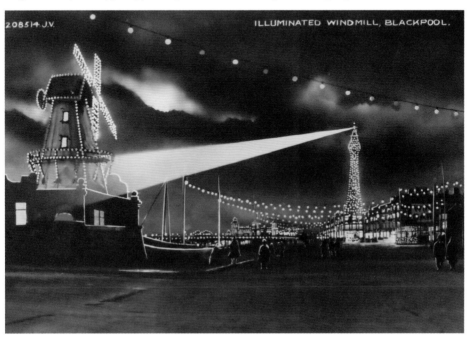

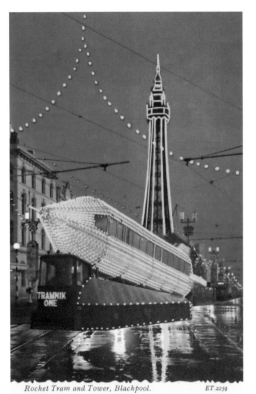

Rocket Tram and Tower, Blackpool.　　　ET.2259

The Illuminations III

If you were aged between five and eleven (and possibly older), any viewing of 'Tramnik One', the illuminated Rocket tram introduced in 1961, was awesome. This iconic illuminated tram was taken out of service in 1999 and was statically resident on Gynn Square roundabout 2012/14 and should be reinstated. The 1960s also saw the introduction of other illuminated trams including the *Wild West Train, Mississippi Paddle Steamer* and *HMS Blackpool*. Also captivating was the giant sweeping searchlight that roamed the promenade and streets of Blackpool from the top of the Tower. Seen below on a wet evening, the searchlight beam appears to have been 'touched up' in the postcard view.

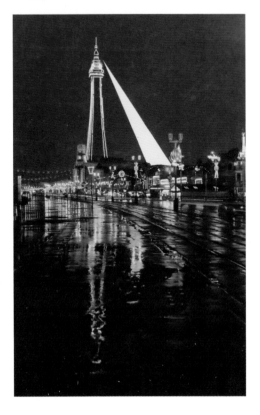

SECTION 5
A MISCELLANY

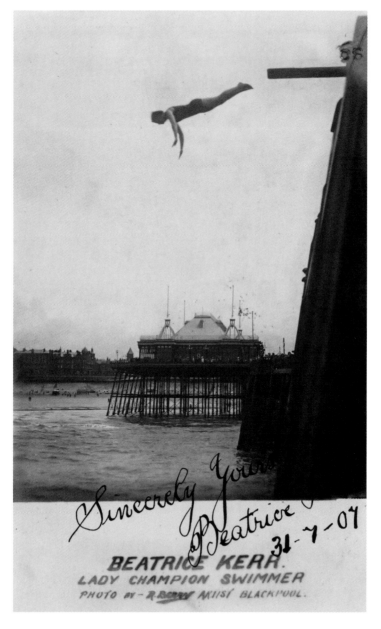

Beatrice Kerr, 1907, champion swimmer.

Derby Baths
Derby Baths opened in July 1939 on Warley Road, North Shore at the corner of the Promenade. With its Olympic-size pool and 10-metre-high diving board it was the venue for school swimming galas, Olympic trials, televised international swimming events and was home for the annual ASA Championships. The steel frame to the art-deco, faience-clad building suffered severely with corrosion and the baths were closed in 1987. The inset is of the pool with the SplashLand slide (1987). In contrast were Cocker Street Baths bought by the Corporation in 1909, where school swimming lessons took place in the freezing cold water and basic changing rooms were the norm. The baths closed in 1973 and the location is now a car park.

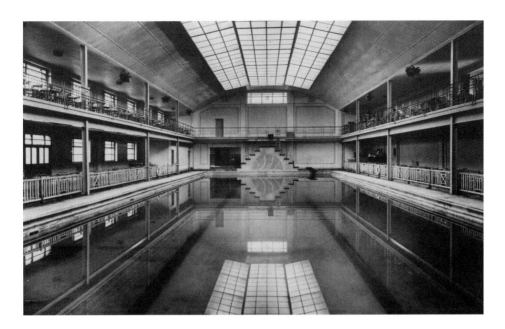

Lido Swimming Pool

The Lido Swimming Pool, Lytham Road, was built in the 1930s and thousands of Blackpool children learnt to swim there. Evacuees from Manchester in the Second World War had their afternoon lessons on the balcony of the swimming pool and after the war there was dancing in the afternoon and evening to the Lido Rhythm Orchestra. It was demolished in 2006 and the Enterprise Centre was opened in 2007. The South Shore Open Air Baths opened in June 1923 and was then the largest open-air baths in the world. It is seen below around 1962 before preferences changed to warmer cheap 'package' holidays and the attendances at the open-air baths fell. They were demolished in 1983 and the Sandcastle indoor swimming complex opened in 1986.

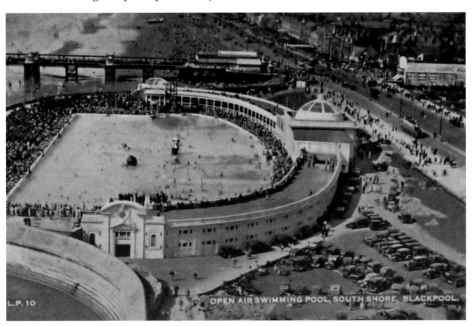

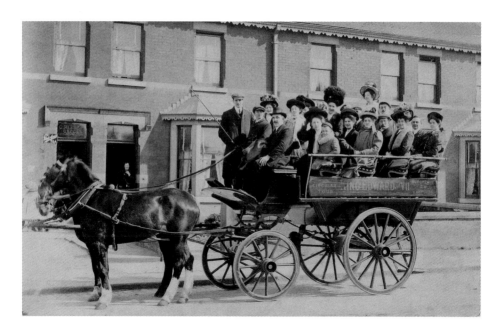

Transport

Horse-drawn wagonettes with cross seating, later replaced by long open-topped motor vehicles, were called charabancs and were popular with visitors in the early 1900s as a means of getting away from the bustle and seeing the nearby surrounding villages and countryside. They are said not to have been comfortable and were superseded by buses in the 1920s. Above is a full load of visitors on a tour to Knott End near the King Edward VII public house on Central Drive. Below is a full motor charabanc (holding more than thirty passengers) from the W. C. Standerwick's King Edward Garage on Chapel Street.

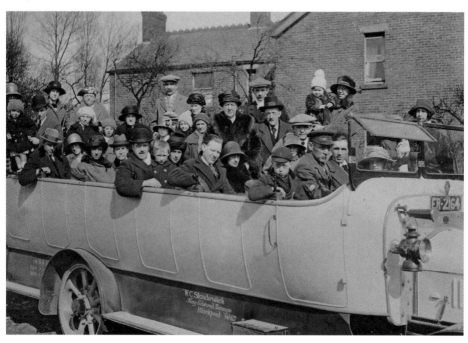

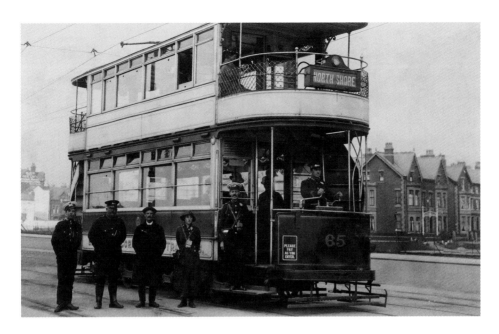

The Trams I

Blackpool's first tramway (the first electric tramway system in the country) was opened in 1885 along with 2 miles of the promenade and was a 'conduit' system. After the Corporation took over the tramway in 1892 it converted the system to an overhead system and operated Dreadnought cars each with a double staircase at each end. The tramway was extended to Gynn Square in 1900 and the double-decked, top-covered Car 65 seen above at the end of Osborne Road, near the southern terminus, was added to the fleet in 1912. In 1935 fourteen 'modern' super double-deckers were introduced with central entrances, as below, near to Gynn Square.

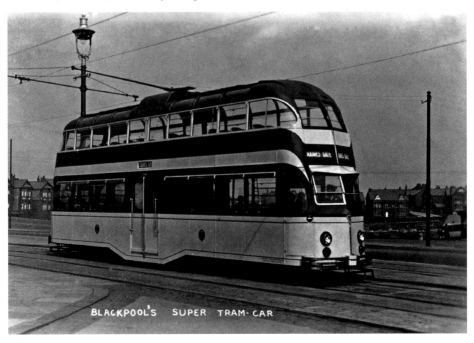

BLACKPOOL'S SUPER TRAM-CAR

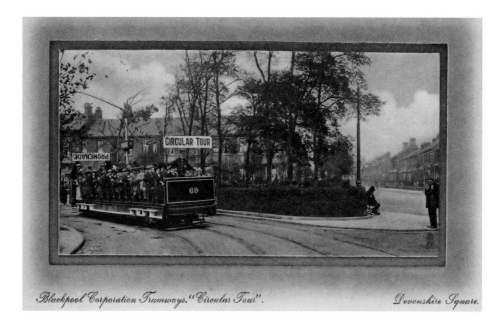

Blackpool Corporation Tramways. "Circular Tour". *Devonshire Square.*

The Trams II

The Circular Tour tram route from Talbot Square via Lytham Road, Waterloo Road, Marton, Whitegate Drive, Church Street, Abingdon Street and Clifton Street featured the open single-deck 'toast rack' cars which were first introduced in August 1911. The postcard view above is a staged picture at Devonshire Square, with Car 69 appearing to be travelling the wrong way. The tram route closed in the 1960s. The advertising picture of Raikes Garage Co. Ltd, at 272 Church Street, states that the garage was an agent for Rover, Hillman and Crossley cars and that it had 'cars for hire'. The Managing Director was Mr E. Sutcliffe.

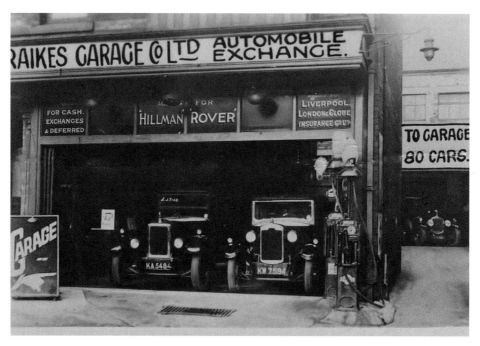

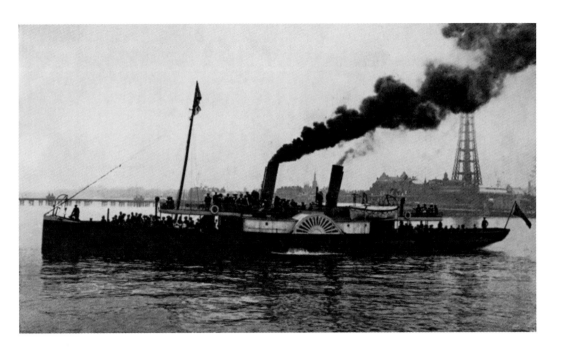

Steamers and Flying

Paddle steamers operated from North Pier from the 1860s and sailed to places including, Douglas (IoM), Southport, Liverpool, Llandudno and Morecambe with fierce competition from the Central Pier steamers. *Belle,* a pleasure steamer, joined the North Pier fleet in 1895 and ran daily during the season. Paddle steamer sailings ended in 1939 and an attempt to reintroduce sea excursions from North Pier in 1992 was not a success. Below, three Avro 504Ks are seen providing pleasure flights from the beach in 1919. In the early years of flying Blackpool was at its heart, hosting the first officially recognised flying meeting in Britain (October 1909) and having Britain's first daily air service from South Shore beach to Southport and Manchester.

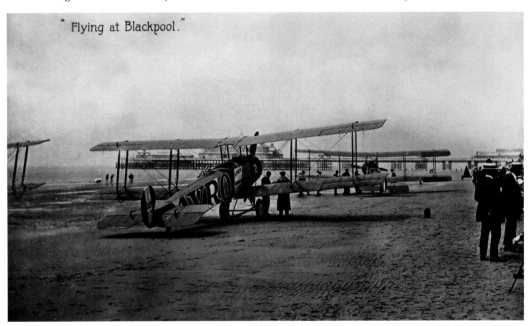

"Flying at Blackpool."

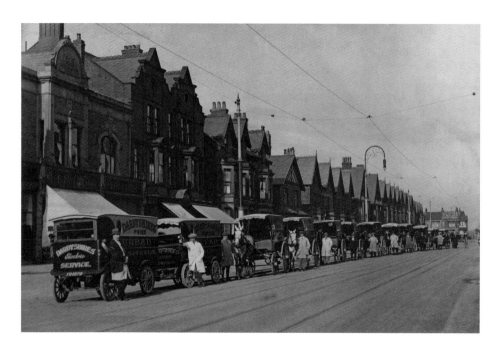

Derbyshire's Electric Service

The picture above of two electric bread vans with several horse-drawn carts on Station Road in the 1930s captures the closing of the horse-drawn-cart era. Derbyshire's Prize Bread Co. Ltd was located at No. 27a Caunce Street and had its diamond jubilee in 1968. In 1971 it amalgamated with Burtons and in the early 1980s became part of the Warburton Group. The 1938 picture below shows four new Metrovick 10/14 electric milk floats at the Blackpool Co-operative Dairy on George Street, which served as a production and distribution factory for almost seventy years. The dairy building and chimney have been demolished and the land is now vacant.

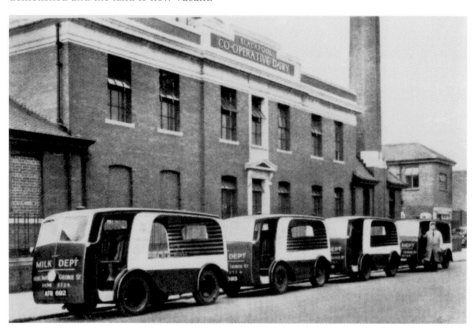

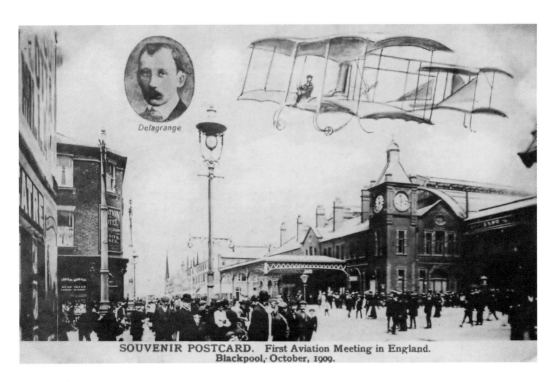

Delagrange

SOUVENIR POSTCARD. First Aviation Meeting in England.
Blackpool, October, 1909.

Railway 1

The railway was extended from Poulton and the first train arrived at Talbot Road Station on 29 April 1846. The station was re-built in 1898 and the Dickson Road entrance is seen above in the 1909 postcard view taken from Topping Street at its junction with Talbot Road. The postcard has been overprinted to celebrate the aviation meeting at Squires Gate that year. Below is a July 1967 view from the roof of Talbot Road Bus Station, looking across the roof of North Station and its platforms with Talbot Road on the right. The station building fronting Dickson Road was demolished in 1974 and the terminus moved back to the excursion building on the left.

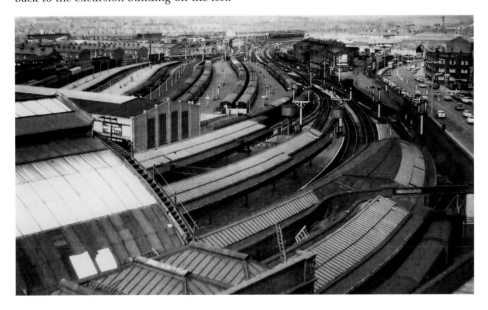

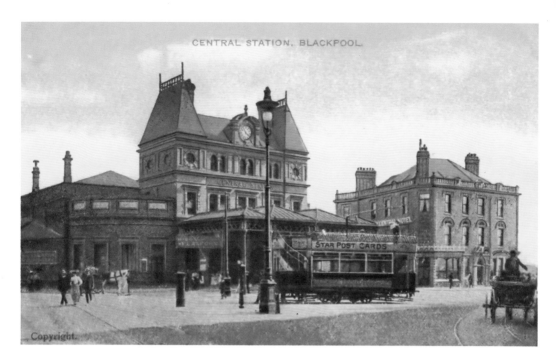

Copyright.

Railway II

The line to the originally named Hounds Hill Station was extended from South Shore Station (opposite Station Road) on 6 April 1863. It was re-named Central Station in 1878. The Marton line opened in 1903 and in 1911 it was said to be the busiest railway station in the world. It is seen above in around 1905 with the re-built New Inn (1896) to the right. The station closed in 1964 and the Coral Island complex now occupies the site. The temporary light railway (below) ran for about four months from February 1911 transporting sand from South Shore beach to the Princess Parade promenade extension works and was dubbed 'the Sands Express'. It used engines named *Horbury*, *Netherton* and *Annie*.

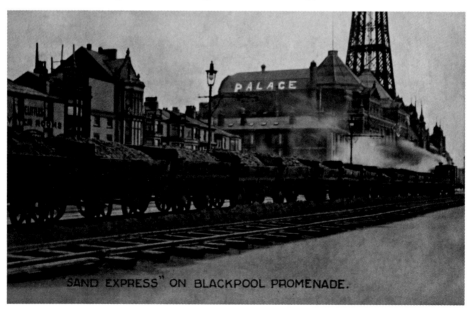

"SAND EXPRESS" ON BLACKPOOL PROMENADE.

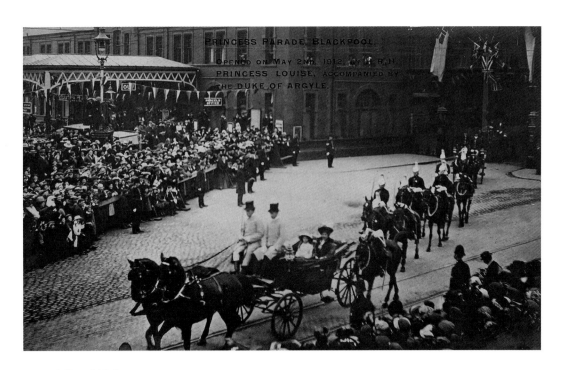

A Royal Visit

The first royal visit to Blackpool was by Queen Victoria's daughter, HRH Princess Louise, on 1 May 1912. She is seen above leaving North Station, Talbot Road with her husband the Duke of Argyll by carriage. The following day she opened the newly constructed Princess Parade. On Tuesday 8 July 1913, the reigning monarch King George V and Queen Mary visited Blackpool during their tour of over thirty Lancashire towns. The King and Queen drove along the promenade between South Shore and the Gynn and then briefly met civic dignitaries at the Town Hall.

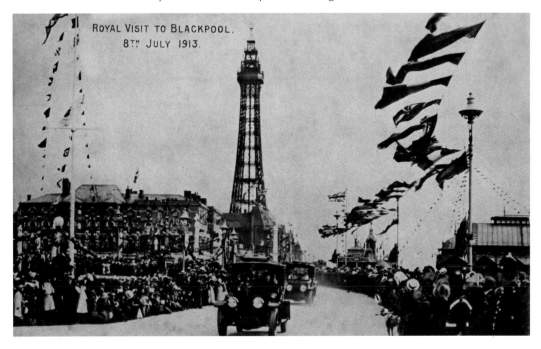

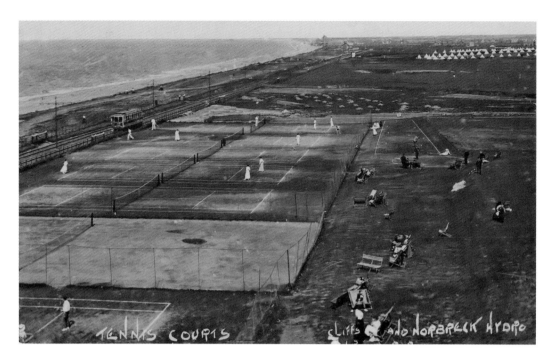

Queen's Promenade

The 1917 postcard above, shows the Norbreck Hydro Hotel tennis courts and the open expanse of the land to the north. To the left, a tram of the Blackpool & Fleetwood Tramroad Company can be seen before Queen's Promenade was extended from Norbreck to Anchorsholme in 1932. The white tents in the distance to the right are in the west field of the Bispham Lodge (YMCA) Holiday Camp. The postcard below (unused but dated September 1946) is an advertising card produced by Dorothy to promote what was probably her new hairdresser's shop at No. 72 Guilford Avenue, Norbreck, near the junction with Fleetwood Road. The shop is now 'Shades Nail and Hair Design'.

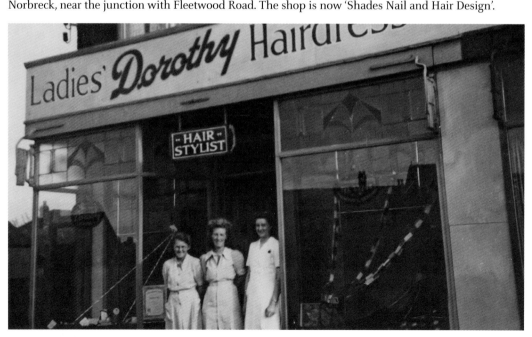

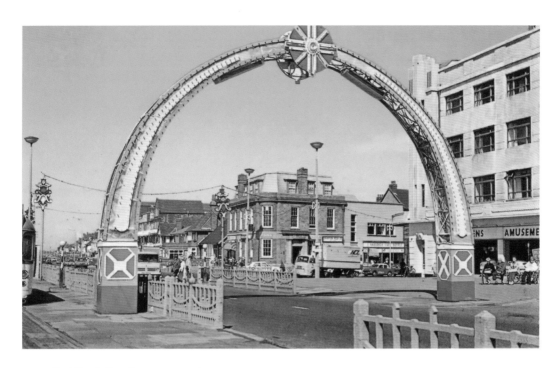

Red Bank Road

An illuminated 'Welcome' arch on the promenade at the Red Bank Road, Bispham (northern) end of the Illuminations is a regular annual feature. To the right are the 1936 Queens Mansions apartments with Harts Amusements below. The boulder clay cliffs rising to a height of 100 feet and the open expanse of beach at North Shore, approximately just north of where the Boating Pool now stands, are seen below in the early 1910s postcard view. Sea wall works utilising the beach gravel were commenced to Arundel Avenue in 1917.

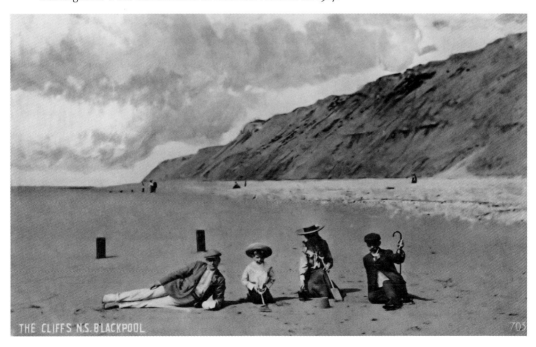

THE CLIFFS N.S. BLACKPOOL

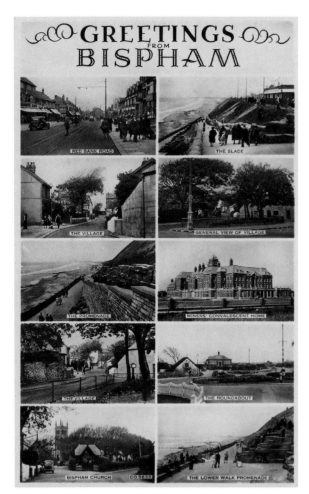

GREETINGS FROM BISPHAM

RED BANK ROAD

THE SLADE

THE VILLAGE

GENERAL VIEW OF VILLAGE

THE PROMENADE

MINER'S CONVALESCENT HOME

THE VILLAGE

THE ROUNDABOUT

BISPHAM CHURCH

THE LOWER WALK PROMENADE

Bispham

Bispham features in the Domesday Book and was a village in its own right until 1910 when it became the Urban District of Bispham with Norbreck. It was amalgamated into Blackpool on 1 April 1919. The multi-card of Bispham was posted in 1962 and depicts Bispham's prominent features at that time, just before the village was 'redesigned'. The Bispham (and Norbreck) Gala procession of July 1913 is seen below with the children in fancy dress costumes on Red Bank Road in the village centre passing Ivy Cottage Tea Rooms en route to the Bispham Gala fields for the crowning of the Gala Queen.

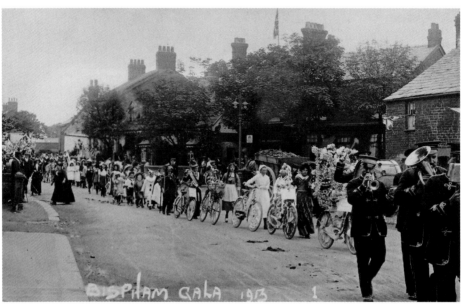

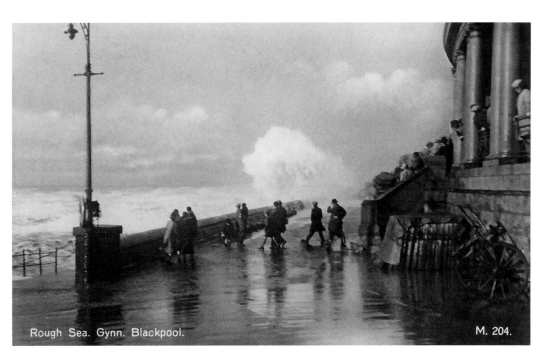

Rough Sea. Gynn. Blackpool. M. 204.

Gynn Square

Rough seas at Blackpool were themselves an 'attraction' and the postcard above shows visitors risking a soaking at high tide on the Lower Walk, at Gynn Square in 1926. The whitewashed Gynn Inn which dated from 1745 is seen below around 1905, with the tracks of the Blackpool and Fleetwood Tramway Company sweeping past it and onwards up Queens Promenade. The Gynn Inn closed in May 1921 to make way for road improvements and was demolished in August 1921. Its site encompassed what is now approximately that of the roundabout in Gynn Square.

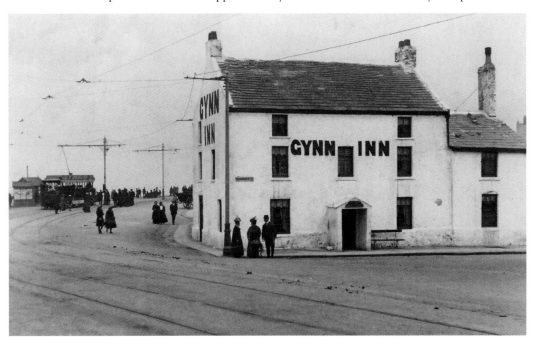

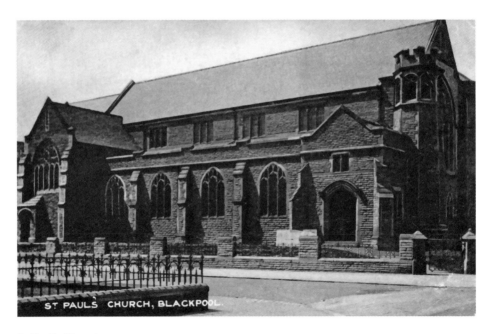

St Paul's Church

St Paul's Church, Egerton Road, North Shore began as a 'tin church' in 1895 but due the growing prosperity of North Shore a permanent building was required and the new church was consecrated on 19 July 1899 by the Bishop of Manchester. With the deterioration in the holiday trade, the use of the church fell and it closed in 1993. It was sensitively transformed into St Paul's Medical Centre and the clock tower was retained. The postcard view below is of the sea wall just south of Cocker Square c. 1906 before the works to Princess Parade were completed and joined to the 'North Shore Works' completed in 1899 between Cocker Square and Gynn Square.

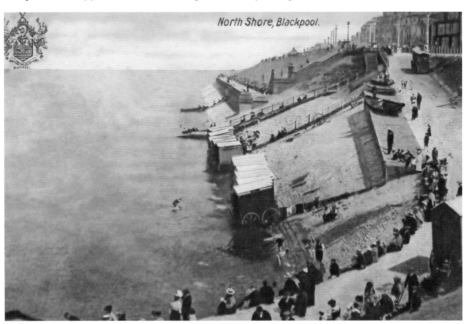

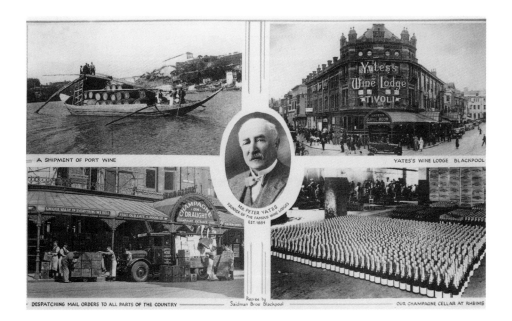

A SHIPMENT OF PORT WINE · MR. PETER YATES FOUNDER OF THE FAMOUS WINE LODGES EST. 1884 · YATES'S WINE LODGE BLACKPOOL · DESPATCHING MAIL ORDERS TO ALL PARTS OF THE COUNTRY · Repros by Saidman Bros Blackpool · OUR CHAMPAGNE CELLAR AT RHEIMS

Yates's Wine Lodge

Peter Yates opened the first Yates's Wine Lodge in Oldham in 1884. Yates's Talbot Square premises opened in 1896 on the ground floor of what was originally the Theatre Royal (1868) and later (1880) the Blackpool Free Public Library and Reading Room. Yates Bros Ltd converted the upper floor into the Tivoli Cinema and in the 1970s it was the Talbot Bingo Club. On 15 February 2009, the building was destroyed by fire and the prominent site remains undeveloped. The Boots Building, together with the municipal offices and Riley & Sons drapers in Corporation Street, caught fire on 7 October 1936 and had to be demolished. Sadly, newly married fireman Raymond Laycock was killed fighting the blaze.

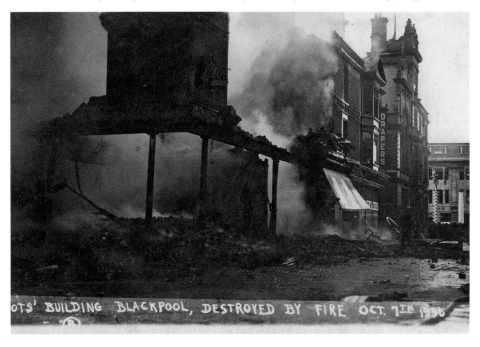

OTS' BUILDING BLACKPOOL, DESTROYED BY FIRE OCT. 7TH 1936

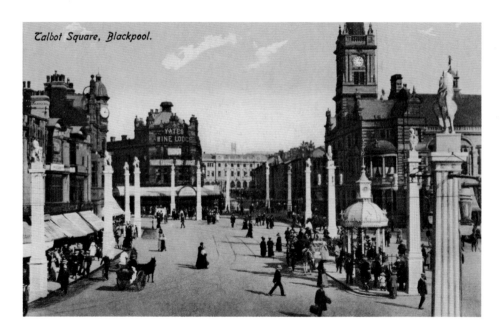

Talbot Square, Blackpool.

Talbot Square

The postcard view above of Talbot Square, the Town Hall, the drinking fountain and the numerous white decorative pillars is thought to be from 1913 just before the visit of King George V and Queen Mary in July of that year. Donkeys on the beach have been a regular children's favourite and tradition since the 1890s. A donkey 'charter' has been in place since 1944 governing the use of donkeys on the beach and today strict regulations are in place to safeguard the health and welfare of the donkeys. They now have an hour's lunch and Friday as their day off.

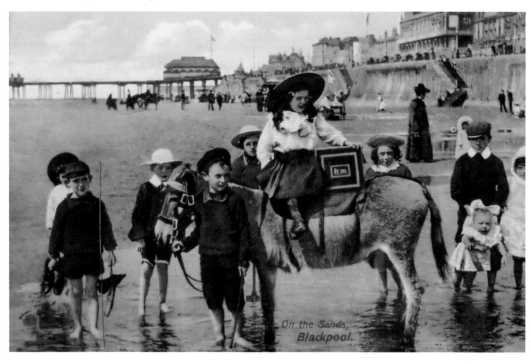

On the Sands, Blackpool.

The Golden Mile

The unusual thing about the 1972 'donkey' postcard is that it is printed inverted. The buildings on the promenade, from left to right, are the Palatine Hotel, demolished in 1974, and now the 'world famous' Palace Discotheque, Woolworths, the Tower and Lewis's.

The postcard view below is of a busy Central Promenade *c.* 1915 and the Golden Mile. To the right, the white faience-clad building had many uses and owners following its opening in 1913, ranging from Redman's Café on the first floor, the Trocadero Hotel and Restaurant, the Huntsman, Ritz Cinema (1935–71) and holiday flats.

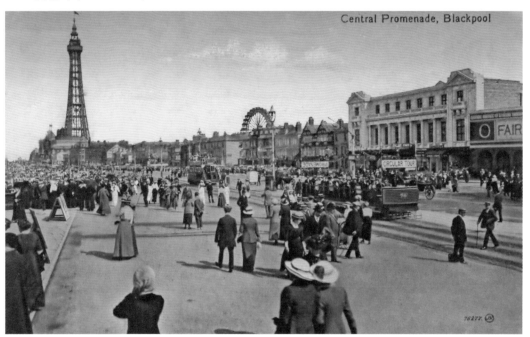

Central Promenade, Blackpool

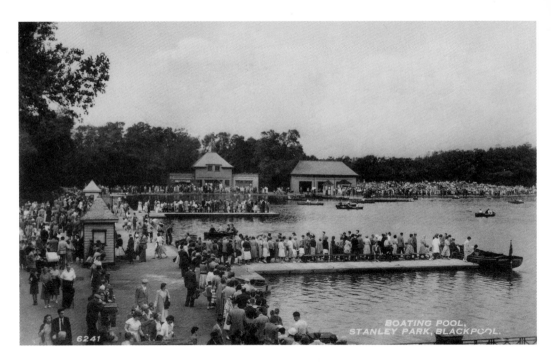

Stanley Park

Stanley Park is Blackpool's largest municipal park and was officially opened in 1926 by Lord Derby. The view above shows the popularity of the park and boating on the 22-acre lake in the early 1960s. The boathouses in the distance were built in 1935 with an ice-cream shop in the building to the left. The focal point of the park is the Italian Gardens, seen below in the 1955 postcard view, with its central fountain made from Italian marble, its statues and its well-maintained and colourful flower beds.

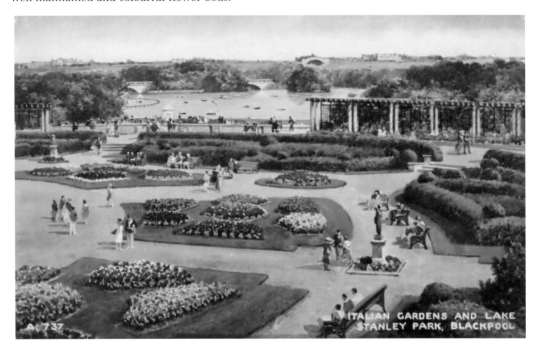

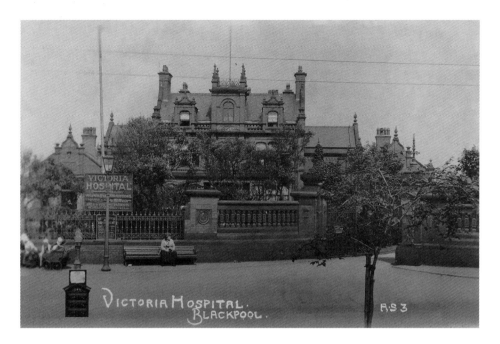

RNLI

A hospital on Whitegate Drive opened on 25 August 1894 with twelve beds and three cots. It became the Victoria Hospital in 1897 and moved to Whinney Heys in September 1936. The Whitegate Drive site became the Municipal Health Centre and in November 2009 the impressive Whitegate Health Centre opened. The RNLI Lifeboat House was on Lytham Road from 1864 to 1937 until the lifeboat house adjacent to Central Pier was built. Blackpool's first lifeboat, the *Robert William*, was first launched on 20 July 1864 and Robert Bickerstaffe was coxswain from 1864 to 1887. The second lifeboat was the *Samuel Fletcher* (1885), which was replaced by a new Watson-class lifeboat in 1896 (also the *Samuel Fletcher*) and was used as a pleasure boat on Stanley Park for many years.

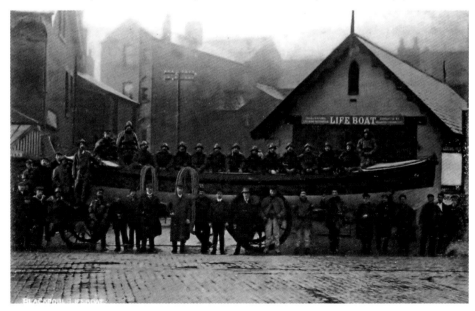

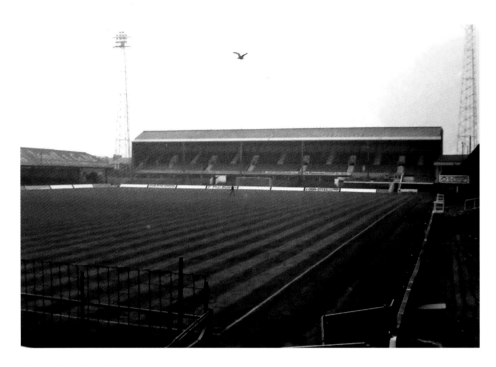

Bloomfield Road I

The picture above was taken after an evening match in September 1982. Founded in 1887, Blackpool FC played at Bloomfield Road from 1901 and have had a 'rollercoaster' existence, winning the 1953 'Matthews' FA Cup final, finishing runners-up in the First Division 1955/56 season, finishing twenty-first in the Fourth Division in 1983 and being promoted to the Premier League in 2010 but demoted in 2011. Blackpool Borough Rugby League Club first played in the Rugby League in 1954 at St Anne's Road Greyhound Stadium (Stadium Road). From 1962 until 4 January 1987 they played at Borough Park on Rigby Road. The picture below is from the stand during a Blackpool Wren Rovers vs Maghull game.

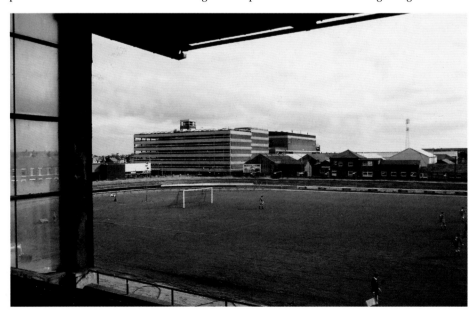

Bloomfield Road II

Above is a 1994 view of the No. 1 Club on Bloomfield Road which moved to the south-western side of what was Bloomfield Road Bridge around 2010. The building has since been converted into the Sam Tai Casino, Bar and Restaurant. In a 1936 Tower and Winter Gardens programme, Misses E. A. & M. A Smith (established 1900) advertise as 'High Class Confectioners and Pastry Cooks' at Nos 21, 23 and 279 Lytham Road. The postcard below shows the shop frontage and an inside view of the stylish café at No. 227 Lytham Road in the 1930s. The Lido Royal Café, taking its name from the nearby (demolished) Lido Pool, now resides at Nos 277–9 Lytham Road.

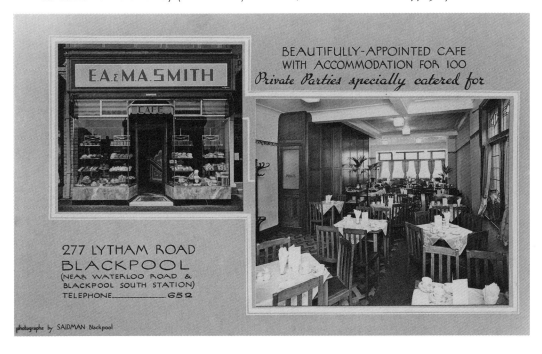

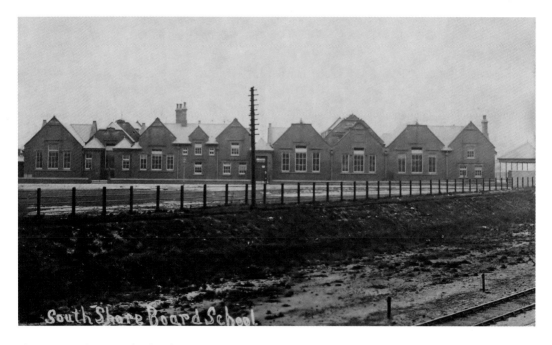

Thames Road Council School

Thames Road Council School, above, is viewed across the railway tracks from what is now the Pleasure Beach's Bond Street car park. It opened in April 1903 but was originally the South Shore Board School, replacing the National School in Dean Street. The school accommodated 1,080 pupils and the first headmaster was Mr S. S. Lomax who was assisted by three of his four daughters who were teachers. The postcard view below is looking eastwards from Harrowside towards Highfield Road at its junction with Lytham Road *c.* 1937. On the far left corner is the Farmers Arms and on the far right corner is the Midland Bank, later the HSBC Bank and now an Italian restaurant.

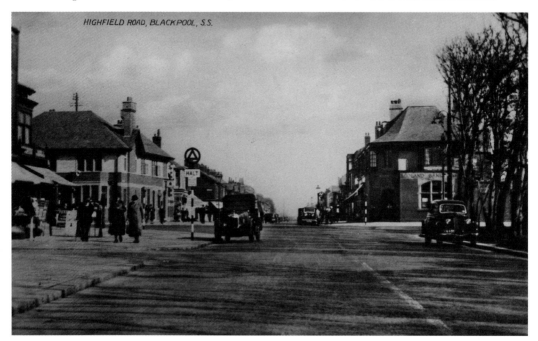

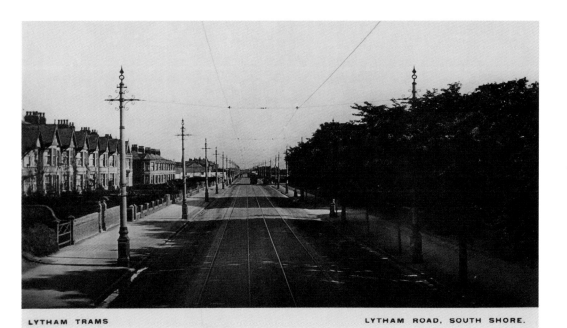

LYTHAM TRAMS LYTHAM ROAD, SOUTH SHORE.

Tramways Route

The postcard view above shows the tramways route from Blackpool to Lytham of the Blackpool, St Annes and Lytham Tramways Company Limited, on a nearly deserted Lytham Road, looking south from near Highfield Road. The Squires Gate route opened on 28 May 1903 and closed on 29 October 1961. Like the arch at Bispham, the Illuminations 'Welcome' arch on the New South Promenade, South Shore (below) marks the southern boundary of the Illuminations and is an established and colourful feature, now in the form of an LED display.

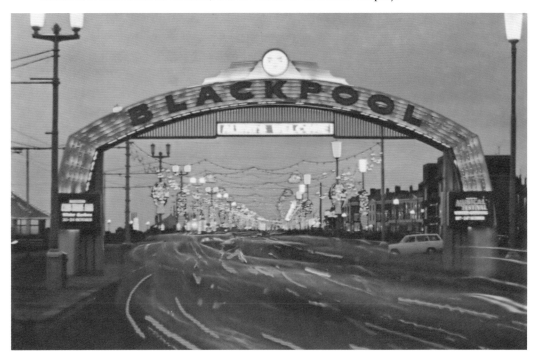

SOURCES & ACKNOWLEDGEMENTS

Most of the cards in this book are from my own collection. I would like to particularly thank Ted Lightbown for his observations on the text of the book. I also thank: the late Alan Stott (Cocker Street Baths), Ray Maule (Blackpool Football Club and Rugby League Ground), Mark Fynn (Tram 65, Streamline Tram, Front of Tower), Peter Dumville (Tower), Dr P. Thompson (Charabanc tour), P. Williams (Milk floats), Mark Fisher for his permission to use the modern 'Comic' card, Nick Moore, Andy Gent, Amounderness and Blackpool Council publications.

ABOUT THE AUTHOR

Allan was born in Blackpool and attended the three Claremont Schools, the new Warbreck Boys' School, Blackpool Grammar School and the new Sixth Form College. He has a degree in Civil Engineering from Sheffield Poly and worked in the Borough Surveyor's Department of Blackpool BC from 1978 to 1989. He later studied law at Nottingham Law School and was called to the Bar in 1996. He now acts as an adjudicator and arbitrator in construction disputes. Allan is married with four great children. His fascination with old Blackpool scenes started in Sheffield in 1975 at a 'collectors' fair and has not stopped since. This is Allan's sixth Blackpool postcard book. The royalties from this book will be donated to Brian House Children's Hospice, Bispham.

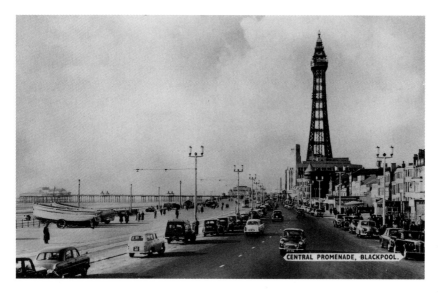

Central Promenade c. 1962.